IMAGES
of America

THE NEIGHBORHOODS OF
LOGAN, SCOTT, AND THOMAS
CIRCLES

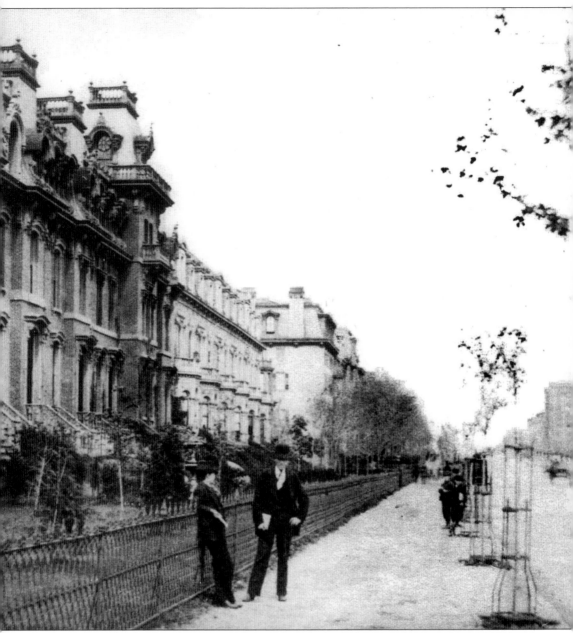

This rare image of K Street between Fourteenth Street and Vermont Avenue about 1880 shows the residential nature of the area at the time. To the north, Logan, Scott, and Thomas Circles offered larger, individual lots for homes that were then considered at the edge of the civilized city. (Courtesy Prints and Photographs Division, Library of Congress.)

IMAGES
of America

THE NEIGHBORHOODS OF LOGAN, SCOTT, AND THOMAS CIRCLES

Paul K. Williams

ARCADIA

Published by Arcadia Publishing,
an imprint of Tempus Publishing, Inc.
2 Cumberland Street
Charleston, SC 29401

Printed in Great Britain.

Library of Congress Catalog Card Number: 2001094686

For all general information contact Arcadia Publishing at:
Telephone 843-853-2070
Fax 843-853-0044
E-Mail sales@arcadiapublishing.com

For customer service and orders:
Toll-Free 1-888-313-2665

Visit us on the internet at http://www.arcadiapublishing.com

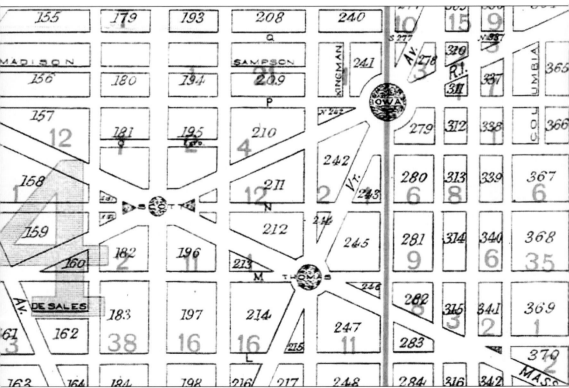

This detail of an 1894 map of the City of Washington shows, in large numerals, the total number of outside privies or outhouses that were located on each Square (three digits). Scott Circle is seen at the left, Iowa (later Logan) Circle at the top, and Thomas Circle to the right. They were mapped along with a series of maps of reported infectious diseases, prevalent at the time. (Author's collection.)

CONTENTS

ACKNOWLEDGMENTS

The author would like to thank all individuals, friends, and family that provided assistance during the production of this book. Far from a complete history of such complex neighborhoods, its purpose is to build on past resources and offer material herein that will enlighten, enhance, and perhaps surprise both residents and visitors alike. Special thanks also goes to editor Christine Riley for her many trips to the Federal Express box and her patience receiving myriad emails and telephone calls.

Special thanks goes to the staff at the Library of Congress, Prints and Photographs Division; Gail R. Redmann of the Washington Historical Society; and the great staff at the Washingtoniana Division of the Martin Luther King Jr. Memorial Library for their many, many trips back and forth to their outstanding photographic resources. This book is dedicated to David Perruzza, Eric Little, Tim Sloane, Brad Lamm, Charlie Cote, Mark Lehman, Josh Buckman, and Dr. James McAnnally, all of whom had to both witness and rescue me from a lightning encounter just seven weeks before my deadline.

INTRODUCTION

The areas known as Logan, Scott, and Thomas Circles today all appeared on the original Pierre Charles L'Enfant plan for the city of Washington as squares or triangular-shaped areas within the planned city. However, all three were not to be developed for nearly 70 years. Instead, the areas at the edge of the small city during the first half of the 19th century were utilized as orchards, farmlands, grazing for animals, and, during the Civil War, for massive encampments. Until that conflict, Washington had been a relatively small yet important city, but the war effort changed the topographic and social landscape of the city forever.

By 1791, when the federal city's location was officially decided, land speculators had already bought up most of the property, hoping to subdivide it later. In order to encourage building in the new federal city and compensate former owners of the land, the government decided to divide each square in half and publicly auction those lots. The government would also allow the original owners to retain half of the lots in each square to privately sell. This was an effort to raise funds for the development of Washington, although it ultimately failed. The first of these auctions was held on October 17, 1791, and only 31 lots were sold. After a series of failed auction sales, in 1793, the city government began to sell the lots individually.

Camp Barker was located at what is now Thirteenth and R Street, with other large encampments located to the north, such as Camp Campbell at Sixth and Florida (then Boundary) Street. The area known today as Logan Circle was coined Iowa Circle and was utilized as a camp and hangman's gallows for Northern deserters of the Civil War. This massive influx of people during the Civil War served as the origin of the development of Logan, Scott, and Thomas Circle neighborhoods. Troops, freed slaves, and Northern black soldiers, in addition to those that had come to Washington seeking wartime employment, all tended to stay in the city following the conflict.

A remarkable number of churches were created during this period, beginning as small wood frame chapels dotting the landscape. They later evolved into more substantial houses of worship such as the Vermont Avenue Baptist Church on Logan Circle, Foundry Baptist Church south of Thomas Circle, and Lincoln Temple Congregational Church at Eleventh and R Streets. Wealthy Washingtonians built homes on individual lots surrounding both Scott and Thomas Circle as early as the 1860s. Well-known commercial areas located just south of all three Circles, such as Sixteenth and K Street, were then lined with large mansions, as were areas near the White House along Lafayette Square. Physical improvements brought on by the municipal government under the leadership of Alexander "Boss" Shepherd, including paved

roads, sewers, water, and landscaping of many of the circles and parks, aided in this development. Like modern times, change took place relatively rapidly with the demolition of homes in the downtown section that were later replaced with commercial buildings and office towers.

The encroachment of the commercial core did not reach Scott and Thomas Circle until after the 20th century; however, when many of the old large mansions began to decay, other parts of the city were deemed acceptable for the wealthy to congregate, including Massachusetts Avenue beyond Dupont Circle and in areas north of the downtown core. Logan Circle had been mostly built up in the early 1870s and attached townhouse developments for the wealthy there remained popular until about 1900. In the decades that followed, Scott and Thomas Circle homes were demolished for commercial uses, and Logan Circle changed dramatically from a wealthy white enclave to an affluent black neighborhood. Unlike Scott and Thomas Circle, however, Logan was able to retain an exclusive residential use, albeit in severe decay by the 1960s.

But even the commercial replacements of Scott and Thomas Circles began decades of decay following the urban riots that shocked Washington in the spring of 1968. Hotels and commercial buildings were closed and often vacant, and what homes were left had been turned into boarding houses and houses of ill repute. A renewed interest in the older architecture inspired a first swell of renovation in Logan Circle in the late 1960s and again in the 1970s before the neighborhood became economically viable by the 1990s. While traces of Scott and Thomas Circles' rich history can be seen in an older structure here and there, it is Logan Circle that has persevered as arguably the most preserved and desirable residential neighborhood in Washington today.

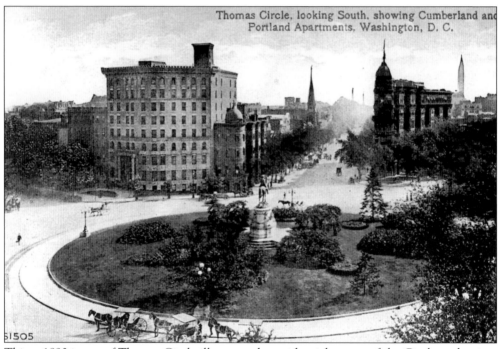

This *c.* 1890 image of Thomas Circle illustrates the residential nature of the Circle at the time despite its proximity to the city center that would eventually encroach northward, calling for the demolition of all the buildings seen here by the 1940s. The large building at left is the Cumberland Apartment building, and to the right is the turreted Portland Flats, Washington's first luxury apartment building, built in 1879. (Author's collection)

One

LOGAN CIRCLE

Washington planner Pierre L'Enfant included Logan Circle on his 1792 plan for the city as Thirteenth Street Circle, later coined Iowa Circle. The open field became infamous later as an executioner's square where spies and deserters from the Civil War were hanged. A trolley car line was installed along Fourteenth Street in 1864, but it was not until the notorious reign of Alexander "Boss" Shepherd of the Board of Public Works that the Circle began to emerge as a densely populated neighborhood. Iowa Circle, itself, was never formally landscaped until 1874.

By the late 1870s, Iowa Circle was beginning to emerge as one of the most desirable residential neighborhoods in the city. It enjoyed this early prominence for a relatively short period, however, as more elaborate and expensive mansions were constructed around Dupont Circle. Ironically, the architecture of this unique neighborhood has been preserved largely because its original occupants moved out, and it began to emerge as a solid middle-class neighborhood. Along with Shaw and LeDroit Park, the area became an intellectual and social center of black Washington shortly after the turn of the 20th century.

In 1930, Congress changed the name to Logan Circle, in memory of Civil War general and senator John A. Logan, who had lived at 4 Logan Circle in 1885. The statue was dedicated by President McKinley in 1901. During the late 1940s and into the 1950s, the neighborhood went into decline, and many of the homes became rooming houses of disputed quality.

Beginning in the late 1970s, new residents started to rehabilitate many of the fine Victorian homes, a continuing trend that has led to a successful revitalization in the 1990s. The area was recognized as a Historic District in 1972.

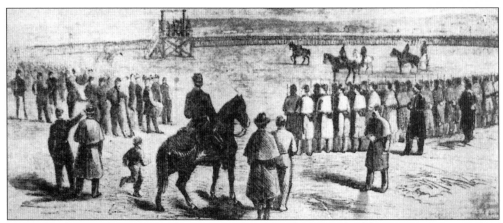

After the design of Logan Circle was completed but before it had become a gracious place of Victorian homes in the 1880s, it served as the site of many Civil War activities. Perhaps its most infamous incident was the hanging execution of deserter Private Lanahan in 1862. This illustration of the event first appeared in *Harper's Weekly* and was later run in an edition of the *Washington Star* on April 1, 1934. (Courtesy Washingtoniana Division, MLK Jr. Public Library.)

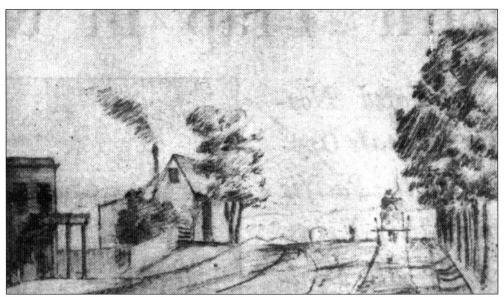

Gen. Montgomery C. Meigs is attributed to having sketched this illustration of Vermont Avenue looking north from M Street as it appeared in 1868. As this sketch suggests, as late as 1870 a notice was published by the mayor's office warning "to the owners of hogs, geese, and goats that . . . the laws allowing these animals to run at large within the Corporation will be strictly enforced." The sketch was later reproduced in the *Washington Star* issue of September 21, 1930. (Courtesy Washingtoniana Division, MLK Jr. Public Library.)

On November 2, 1930, the *Washington Star* included this picture, which was entitled as follows: "The little Christian Baptist, attended by President Garfield, which formerly stood on the site now occupied by the Vermont Avenue Christian Church." (Courtesy Washingtoniana Division, MLK Jr. Public Library.)

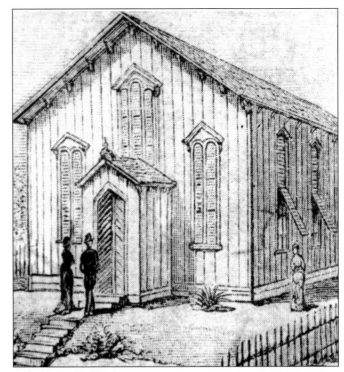

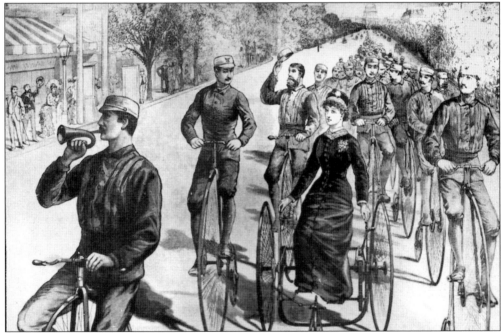

This illustration of the meeting of the League of American Wheelman in Washington D.C. first appeared in *Frank Leslie's Illustrated Newspaper* in May 1884. During the 1880s, an annual "high cycle" race was run around Logan Circle, and on May 9, 1882, a building permit was taken out by the Washington Bicycle Club to construct a reviewing stand at the center. (Courtesy Washingtoniana Division, MLK Jr. Public Library.)

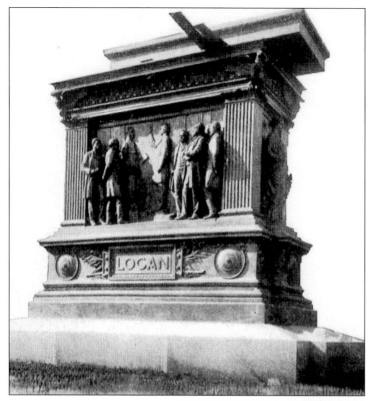

This very rare photograph of the Logan Statue in Logan Circle was included in the book *Everyday Life in Washington*, apparently during the construction of the art work in the circle. In the place of the equestrian portion of the monument on the top rests a platform in anticipation of the remainder of the work. (Author's collection.)

The architect of the Logan statue base was the noted Richard Morris Hunt, seen here in an 1894 engraving by the Moss Engraving Company. The base is unusual in Washington in that is made entirely of bronze. (Courtesy Prints and Photographs Division, Library of Congress.)

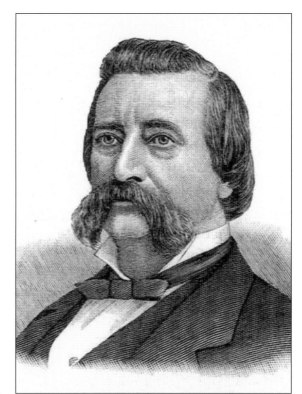

Gen. John A. Logan, the Civil War hero for whom the Circle is named, is seen here in an engraving dated 1887. General Logan and his wife, illustrated here, lived briefly at 4 Logan Circle in 1885. (Both author's collection.)

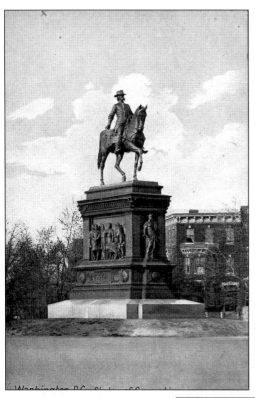

Frank Simmons was responsible for sculpting the General Logan statue, which was installed in 1901 at the center of Logan Circle. Almost immediately after the unveiling, controversy ensued surrounding the figures depicted on the base; General Logan is seen receiving his post from President Chester Arthur in 1879, though Arthur did not become president until 1881. The house in the background is 17 Logan. (Author's collection.)

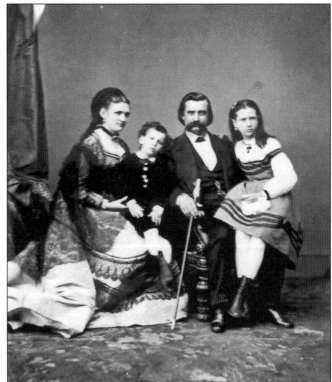

Later a senator, John Logan and his family were artistically captured by noted Civil War photographer Mathew Brady. (Courtesy Prints and Photographs Division, Library of Congress.)

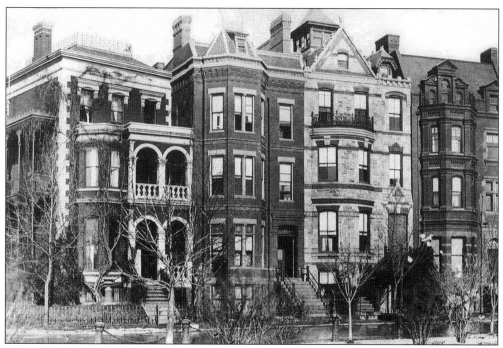

The homes between 4 and 7 Logan Circle are pictured here about 1880. (Courtesy Historical Society of Washington.)

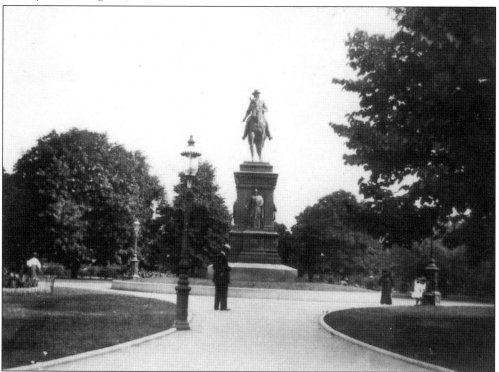

Logan Circle is depicted here on July 14, 1907. (Courtesy Washingtoniana Division, MLK Jr. Public Library.)

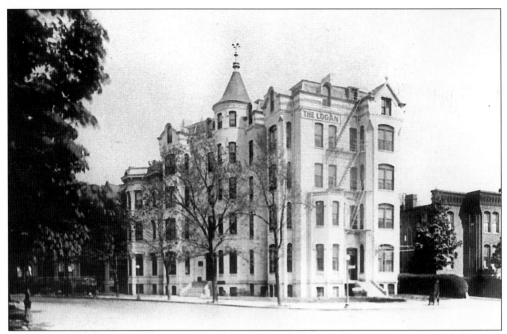

This *c.* 1906 image shows the Logan building that once stood at 30 Logan Circle. The structure was actually an 1883 expansion of three typical townhouses that each received a two-story addition with a central tower and were connected to 26 Logan, visible on the far left. (Courtesy Washingtoniana Division, MLK Jr. Public Library.)

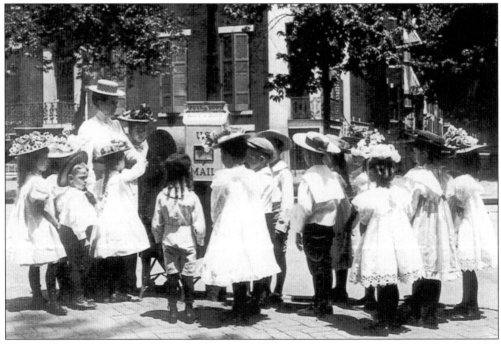

Schoolchildren gather for a lesson on how to mail a letter at the intersection of Tenth and P Street, not far from Logan Circle, in 1889. (Courtesy Prints and Photographs Division, Library of Congress.)

16

Many of the city's police and fire call boxes, such as this one being used by a short officer in the 1920s, remain today in various states of repair in and around Logan, Thomas, and Scott Circles. They were used by officers to call in emergencies, such as this automobile accident or, in the case of fire call boxes, to report fires in an era before each house was equipped with a telephone. Today, these boxes are being adaptively reused as objects of history and art by the D.C. Heritage Tourism Coalition. (Courtesy Washingtoniana Division, MLK Jr. Public Library.)

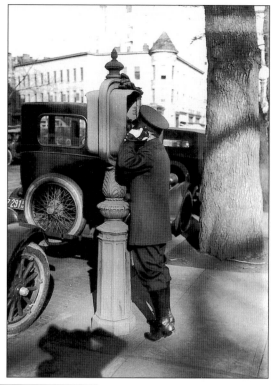

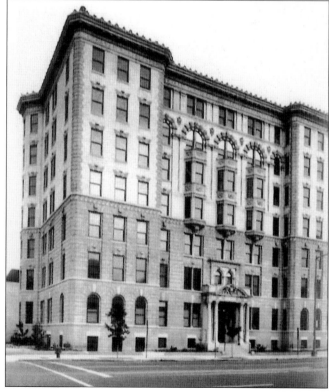

The Iowa Apartment Building at 1325 Thirteenth Street, just south of Logan Circle, was built by prolific architect and Washington developer Thomas Franklin Schneider in 1900. Fifteen years earlier, he had completed the Cairo Apartments at 1615 Q Street and, throughout his career, would build more than 2,000 individual town homes. The Iowa was converted into condominiums in 1979. (Courtesy Historical Society of Washington.)

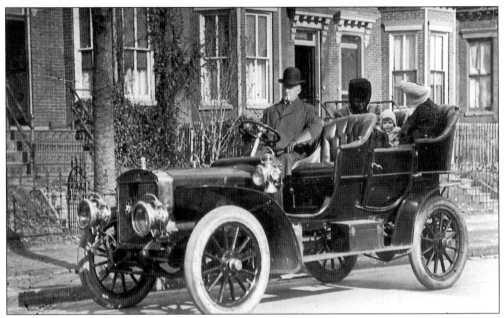

An unidentified man poses in front of his houses at 1103 and 1107 S Street, just north of Logan Circle, along with two veiled women and a small child about 1910. (Courtesy Prints and Photographs Division, Library of Congress.)

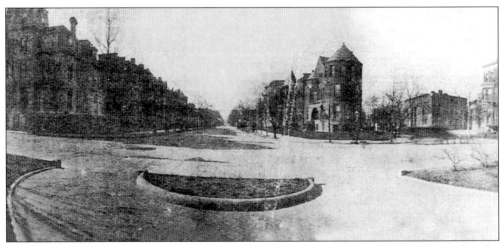

This rare image of the intersection of Rhode Island Avenue and Logan Circle appeared in the *Washington Star* in 1907. (Courtesy Washingtoniana Division, MLK Jr. Public Library.)

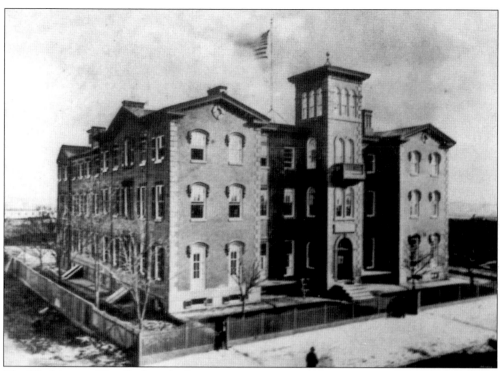

The Washington City Orphan Asylum once operated this large building just north of Logan Circle at Fourteenth and S Street as housing for hundreds of infants. Constructed in 1866, the building was almost immediately utilized by the U.S. State Department before being demolished decades later. (Courtesy Washingtoniana Division, MLK Jr. Public Library.)

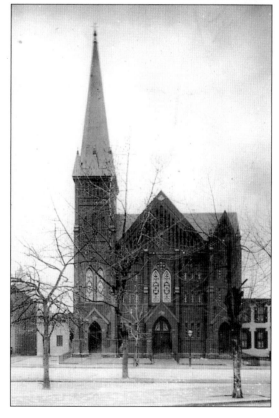

The impressive facade of the Vermont Avenue Baptist Church is pictured here about 1900. Located on the avenue between Q and R Streets, it was often the site of early and influential Civil Rights meetings and public forums, in addition to providing venues for black performers not allowed to entertain in segregated Washington at the time. The shadow of the Civil War–era, wooden frame house to the right is still visible on the north facade of the church. (Courtesy Historical Society of Washington.)

19

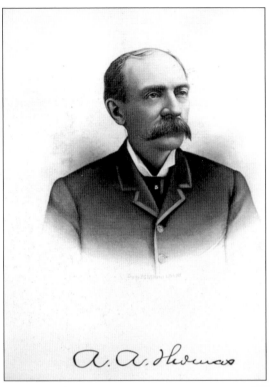

This photograph of the owner of 1314 Twelfth Street, lawyer Amzi A. Thomas, first appeared in the *Centennial History of Washington*. (Courtesy Washingtoniana Division, MLK Jr. Public Library.)

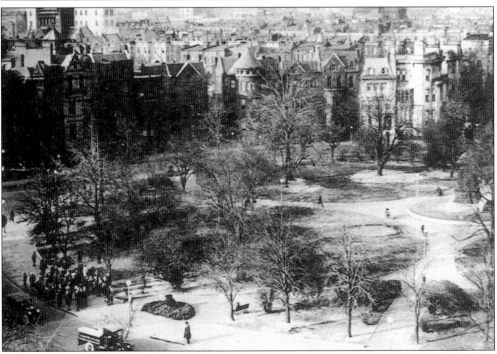

Residents enjoyed the myriad strolling paths located in the Circle. This *c.* 1920 photograph was taken from atop the Logan Apartment building. (Courtesy Prints and Photographs Division, Library of Congress.)

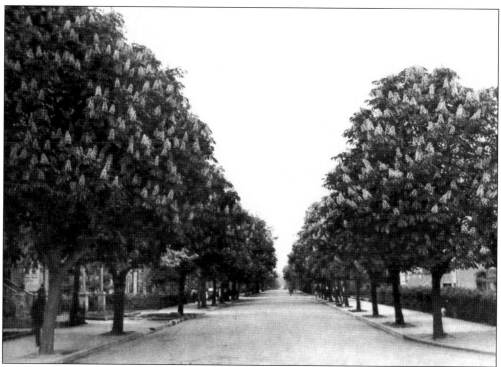

This idyllic spring photograph of horse chestnut trees on Thirteenth Street north of Logan Circle first appeared in *National Geographic Magazine* in June 1913. (Courtesy Washingtoniana Division, MLK Jr. Public Library.)

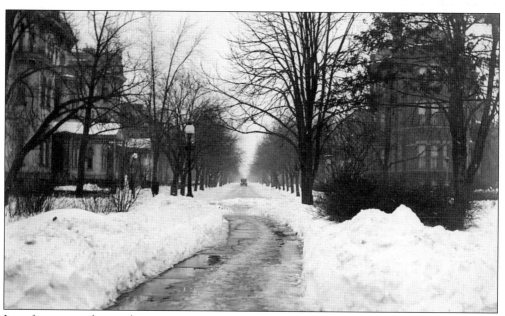

Just four years later, the same intersection appears with a deep snow accumulation in this photograph dated "winter of 1917." The house at 16 Logan is visible at right. (Author's collection.)

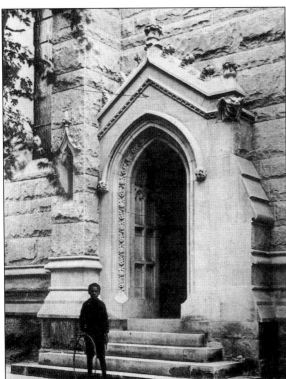

This young chap is pictured about 1900 at the entrance of the Church of the Holy City, Swedenborgian on the southeast corner of Sixteenth and Corcoran Streets, just north of Scott Circle. The church itself was designed in 1894 by architect H. Langford Warren. (Courtesy Harvard University).

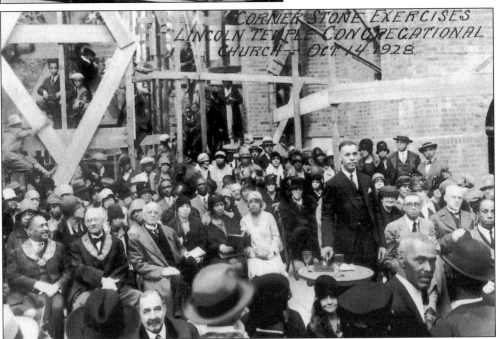

Members of the Lincoln Temple Congregational Church were photographed on October 14, 1928 attending their building's dedication ceremony in the elegant dress of the day. The African-American church is still located at the corner of Eleventh and R Street. (Courtesy Historical Society of Washington.)

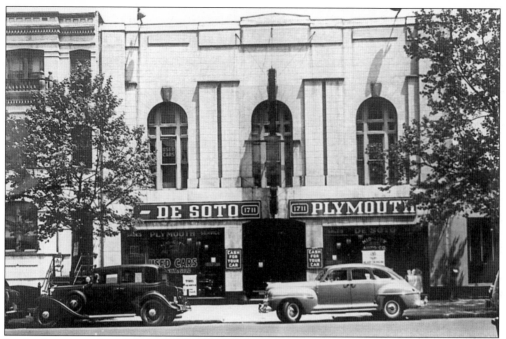

In the first three decades of the 20th century, Washingtonians traveled to the many blocks on Fourteenth Street, north of Logan Circle, to purchase their automobiles from a wide variety of dealerships, including the De Soto dealership located at 1711 Fourteenth Street. (Courtesy Prints and Photographs Division, Library of Congress.)

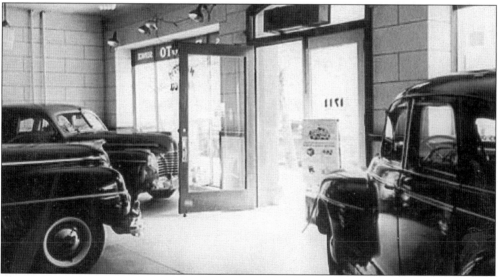

Many of the former car dealership buildings along Fourteenth Street still exist, albeit converted to a variety of new uses, including restaurants, theaters, and retail establishments. Their former use can be detected in the large window openings on the ground floors, and in many cases, large windows on the upper floors that once held brightly lit automobiles. Located on a major streetcar route, the dealerships were certain to tempt passengers on the crowded streetcars to purchase their own form of transportation. (Courtesy Prints and Photographs Division, Library of Congress.)

This Allen automobile was photographed by the National Photo Company while it was parked at Logan Circle. (Courtesy Prints and Photographs Division, Library of Congress.).

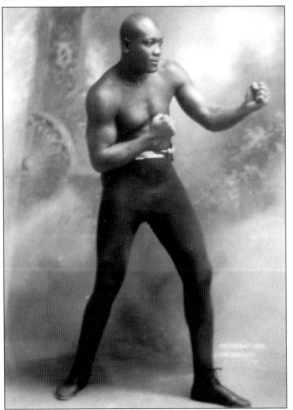

Boxer Jack Johnson (1878–1946) resided not far from Logan Circle, at Thirteenth and R Streets. He was photographed by Otto Sarony in 1909. (Courtesy Prints and Photographs Division, Library of Congress.).

Photographer Carl Van Vechten (1880–1964) captured this view of Civil Rights leader and Logan Circle resident Mary McLeod Bethune on April 6, 1949. (Courtesy Prints and Photographs Division, Library of Congress.)

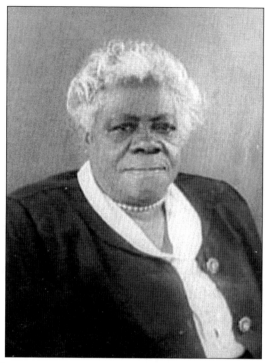

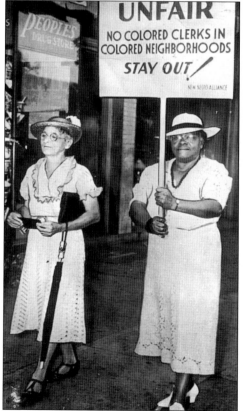

Mary McLeod Bethune led the picket of the Safeway Store located at Fourteenth and U Street in the 1930s, protesting the fact that the white-owned store neglected to hire black employees despite its being located in the predominantly black U Street corridor at that time. (Courtesy Historical Society of Washington.)

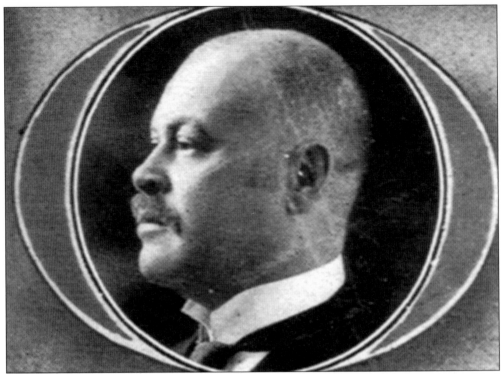

Known as the first African-American registered architect in Washington, John A. Lankford had many commissions in his own neighborhood and along the U Street corridor, including the impressive True Reformer Building situated at 1200 U Street. (Courtesy D.C. Archives.)

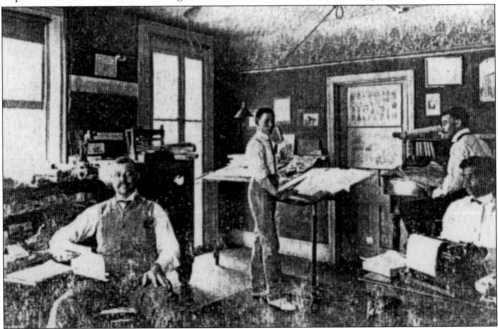

This rare interior view shows the working office of architect John Lankford at 1448 Q Street, an address that also served as his home throughout his career. (Courtesy D.C. Archives.)

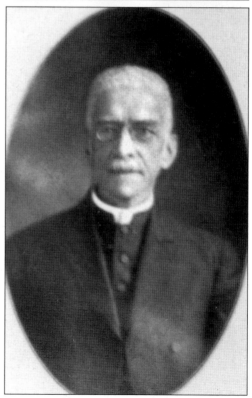

Brothers Archibald and Francis Grimke were constant players in Washington's civil rights activities throughout their 50 years in the city. They resided at 1415 Corcoran Street, just north of Logan Circle. They had both entered Lincoln University in 1866. Francis Grimke is pictured in later years, below. (Above courtesy Moorland-Spingarn Research Center, Howard University; below courtesy Prints and Photographs Division, Library of Congress.)

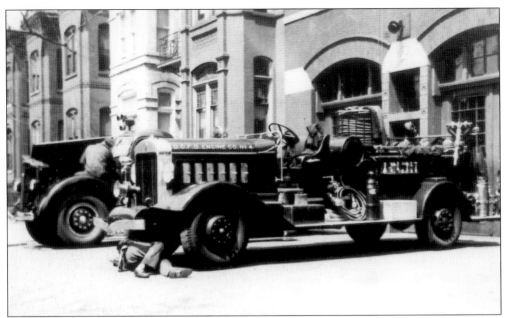

Photographed about 1945, members of Fire Station Number 4 tend to their trucks at the front of their station at 913 R Street. (Courtesy Washingtoniana Division, MLK Jr. Public Library.)

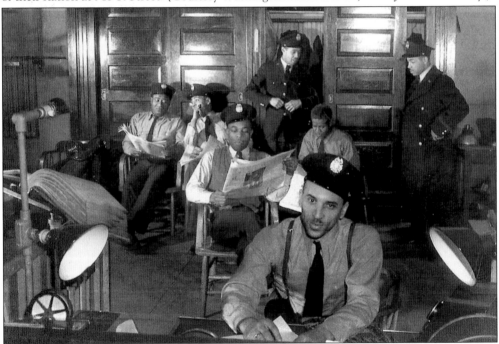

In this image taken by Gordon Parks, members of Fire Station Number 4 are pictured inside their facility in January 1943. The company was organized in 1919 at the request of one of the four African Americans then working for the city; it was his belief that it might be his only opportunity for advancement. Despite being segregated, the company was often asked to assist and fight fires all through out the city. (Courtesy Prints and Photographs Division, Library of Congress.)

Founder of the United House of Prayer for All People, Bishop Charles M. "Sweet Daddy" Grace lived in the luxurious mansion at 11 Logan Circle throughout most of his extraordinary career. He died there in 1960, at the age of 78, but not before stirring up controversy and a settlement with the IRS over his mass fortune stemming from the church. He was known for his long fingernails that were painted red, white, and blue. (Courtesy Prints and Photographs Division, Library of Congress.)

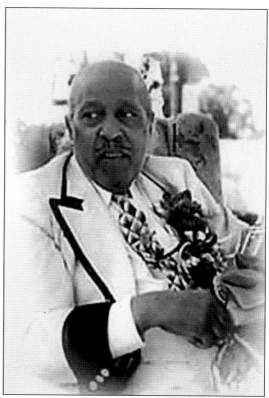

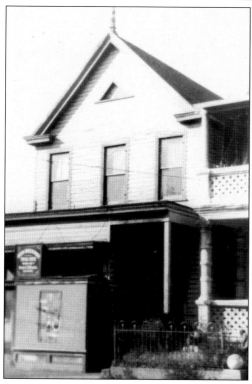

The United House of Prayer for All People had its beginnings in this humble house whose location has been since been obscured. (Courtesy Washingtoniana Division, MLK Jr. Public Library.)

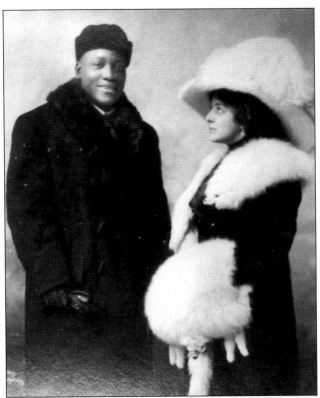

Among the elite African-American residents of Logan Circle were John Arthur and his first wife, Etta, pictured here in 1910. (Courtesy Prints and Photographs Division, Library of Congress.)

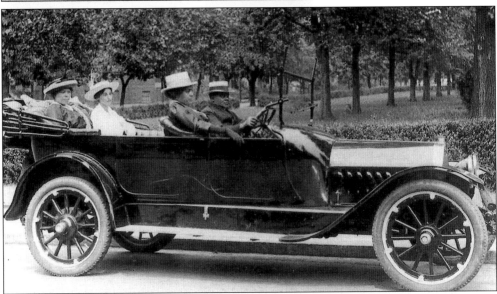

John Goins enjoys his roadster, the tangible result of his successful printing business located on U Street, just north of Logan Circle. His wife, Georgia, pictured next to him at the wheel, was an accomplished musician and educator. Her mother, Sarah L. Fraser, was a physician who opened a practice, located for many years at Thirteenth and Logan Circle, upon her 1911 return from a 20-year stint practicing medicine in the Dominican Republic. (Courtesy Moorland-Springarn Research Library, Howard University.)

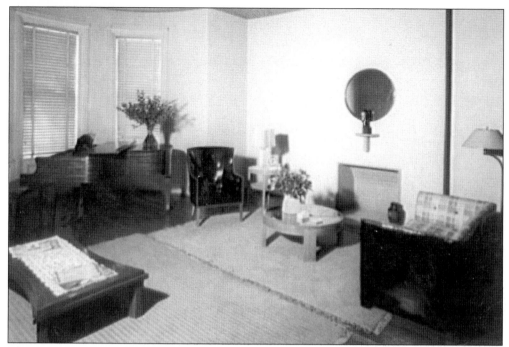

These rare interior images depict 8 Logan Circle during the time it was occupied by Belford V. and Judge Marjorie M. Lawson, who resided there between 1938 and 1958. Prominent in the African-American community, Belford was a leading figure in the Civil Rights Movement in Washington and the first black varsity football player at his alma mater, the University of Michigan. Marjorie Lawson was appointed District of Columbia juvenile court judge by President John F. Kennedy. (Courtesy Prints and Photographs Division, Library of Congress.)

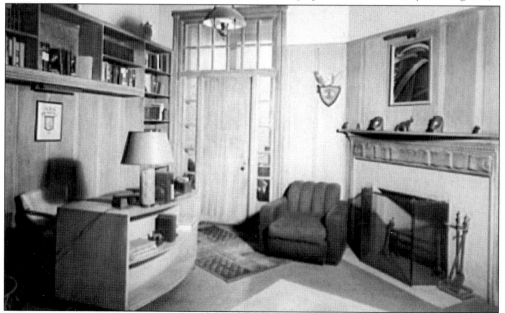

The art deco study of Belford Lawson at 8 Logan Circle is pictured in the 1940s, showing the decoration of the day. (Courtesy Prints and Photographs Division, Library of Congress.)

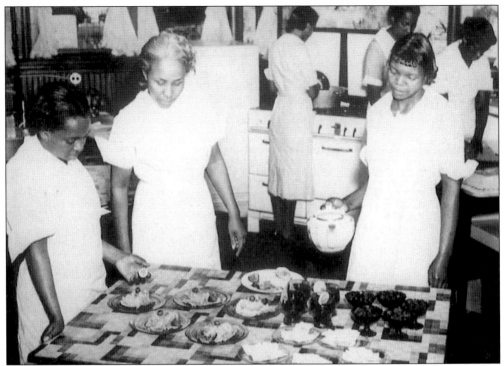

As part of the Household Service Project, the Works Progress Administration established a women's training facility at 1114 O Street during the early 1930s to train African-American women in such duties as cleaning, washing, ironing, cooking, and serving. About 300 women participated in the eight-week course and were placed in private homes by 1939. (Courtesy National Archives.)

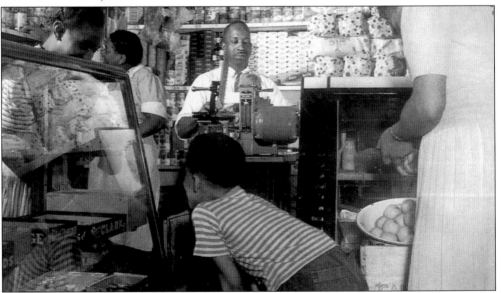

Noted photographer Gordon Parks captured this image of John Benjamin, who operated a convenience store for Logan Circle neighbors on the basement level of 1426 Eleventh Street in 1942. (Courtesy Prints and Photographs Division, Library of Congress.)

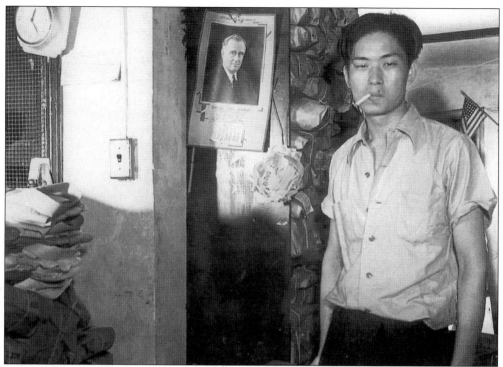

In August 1942, Johnny Low, a Chinese laundry operator, was photographed by Gordon Parks at Low's basement business at 1433 Eleventh Street. (Courtesy Prints and Photographs Division, Library of Congress.)

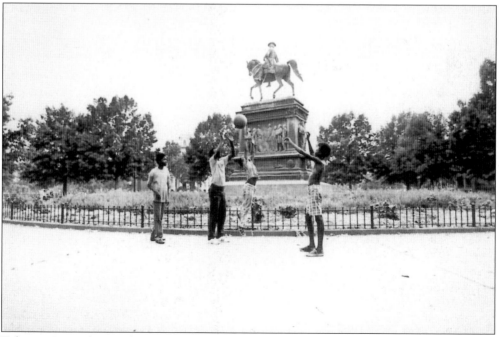

Taken in June of 1971, this image depicts the long grass and neglected appearance of the park at the time. (Courtesy Washingtoniana Division, MLK Jr. Public Library.)

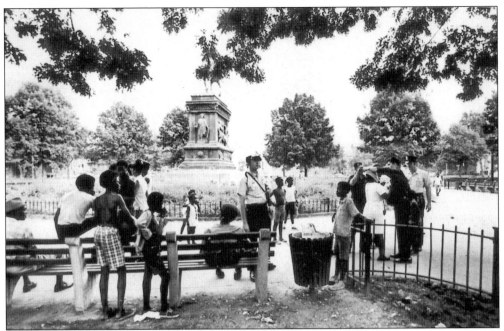

A typical urban park when the *Washington Daily News* ran this photograph of police questioning local youth on June 24, 1971, Logan Circle then experienced much crime and a severe lack of maintenance. (Courtesy Washingtoniana Division, MLK Jr. Public Library.)

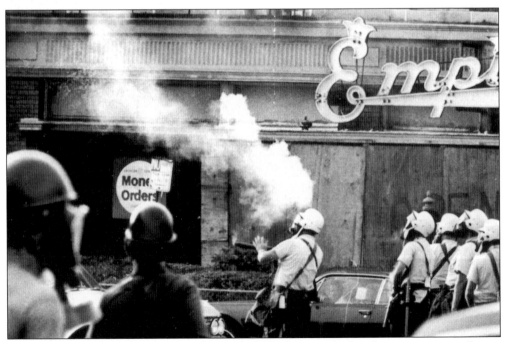

The 1968 race riots that devastated much of Washington had a direct impact on Logan Circle. Police in this scene fire tear gas into a store at Fourteenth and S Street, a building that houses the Whitman-Walker Clinic today. (Courtesy Washingtoniana Division, MLK Jr. Public Library.)

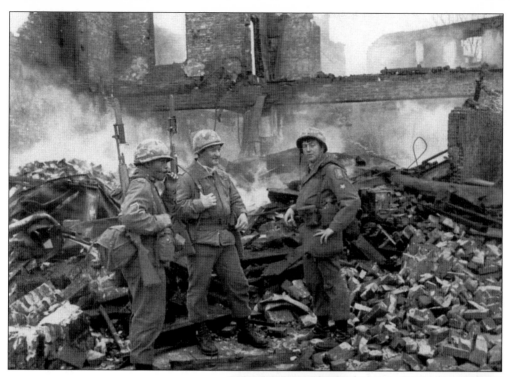

This Fourteenth Street photograph appeared in the *Washington Star* at the height of the riots on April 6, 1968. It was sent out to United Press International with the following caption: "This is not a war scene but a picture taken in downtown Washington early April 6 showing troops on duty near a building completely demolished by fire set by arsonists during a night of burning and pillaging. Four persons were reported dead as a result of the disorders triggered by the slaying of Dr. Martin Luther King." (Courtesy Washingtoniana Division, MLK Jr. Public Library.)

In many cases, buildings stood in decay for decades following the riots of 1968. This young man was photographed by Bernie Boston for the *Washington Star* sitting among the rubble of a burned-out building along Fourteenth Street on August 15, 1968. (Courtesy Washingtoniana Division, MLK Jr. Public Library.)

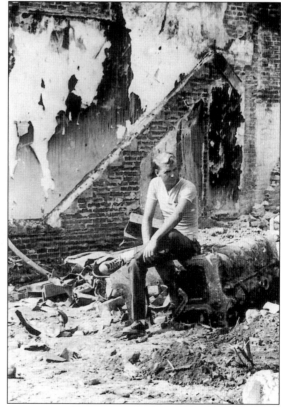

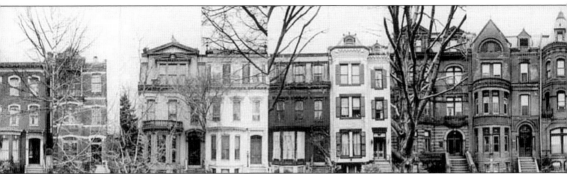

These rows of homes around Logan Circle were photographed in various states of repair by the Historic American Building Survey for documentation purposes in 1973. Those located at 1308 to 1326 Vermont Avenue appear above. (Courtesy Prints and Photographs Division, Library of Congress.)

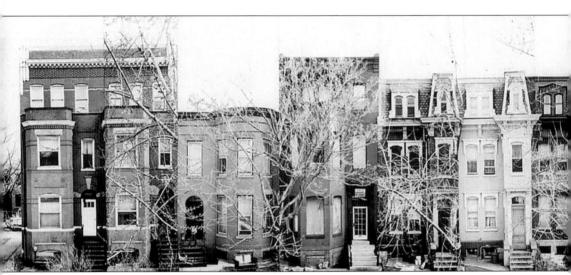

Pictured here are the buildings at 1511 to 1523 Vermont Avenue. (Courtesy Prints and Photographs Division, Library of Congress.)

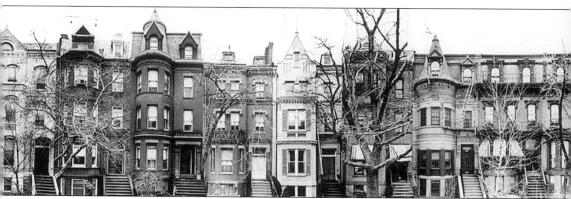

Pictured here are the buildings at 1328 to 1344 Vermont Avenue. (Courtesy Prints and Photographs Division, Library of Congress.)

Pictured here are the buildings at 1501 to 1509 Vermont Avenue. (Courtesy Prints and Photographs Division, Library of Congress.)

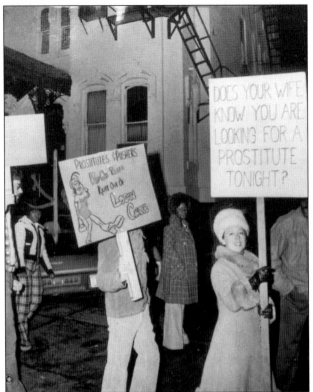

Brave "urban pioneers" and residents of Logan Circle during its initial renovation phase in the 1970s maintained a constant vigil to restore the safety and beauty of the Circle, including a fight against the extensive prostitution that was a mainstay of Fourteenth Street and other locations at the time. Here, protestors march in front of the large mansion at 1300 Thirteenth Street in this photograph by Walter Oates. (Courtesy Washingtoniana Division, MLK Jr. Public Library.)

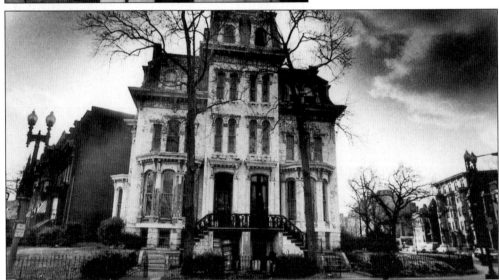

Photographed for the *Washington Star* by Peter Schmick on January 14, 1975, the twin houses at 1 and 2 Logan Circle may have looked forlorn and ghostly, but they were not deserted. The couple that bought the homes soon separated and lived one on each side, each unwilling to renovate in case the other was awarded the house in divorce court. The dispute lasted for decades until the mid-1990s, when the court ordered the sale of the homes, which have now been converted into luxury condominiums. (Courtesy Washingtoniana Division, MLK Jr. Public Library.)

Gen. Ulysses S. Grant, thought to have resided at 1 Logan Circle for a brief time, was caught here on film by famed Civil War photographer Matthew Brady. (Courtesy Washingtoniana Division, MLK Jr. Public Library.)

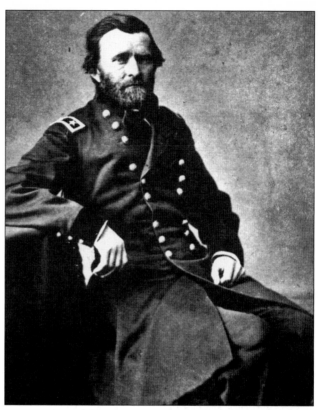

The double house that still stands today at 1 and 2 Logan Circle once served as the downtown location of the Washington Sanitarium, visible here behind the statue of General Logan. (Courtesy Washingtoniana Division, MLK Jr. Public Library.)

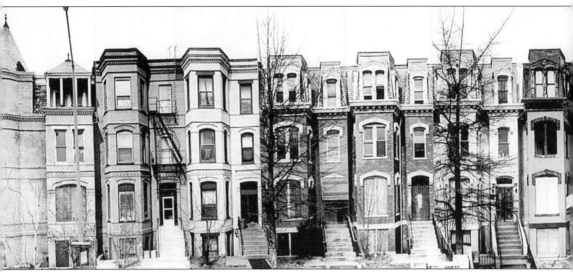

Almost all the homes from 1205 to 1215 Rhode Island Avenue were completely vacant when this 1973 photograph was taken. Note the men boarding up the house at 1215 on the far right. (Courtesy Prints and Photographs Division, Library of Congress.)

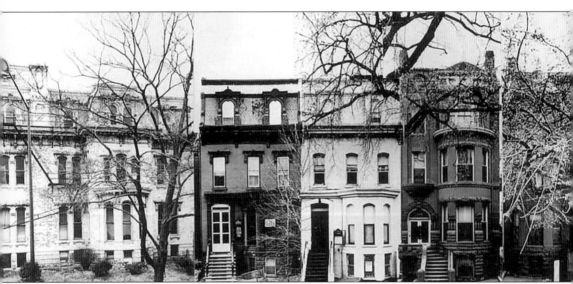

The three buildings in the center of the photograph at 1300, 1302, and 1304 Rhode Island Avenue were constructed in the early 1870s as a matching trio of homes in the Federal style. They later received a mansard roof, while the one at 1304 Rhode Island, home to Dr. Hickling, received an entirely new facade in 1892. The homes are pictured here in 1973. (Courtesy Prints and Photographs Division, Library of Congress.)

One of the first waves of interest to preserve Logan Circle came in 1964, when the next three images ran in the *Washington Star* edition of November 13, 1964. This one depicts an alley near Vermont Avenue at Logan Circle and the National Capitol Parks Commission (NCPC) tour on November 12, 1964. It included members of the "Landmark Committee to Preserve the City." (Courtesy Washingtoniana Division, MLK Jr. Public Library.)

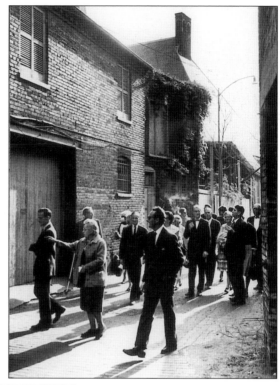

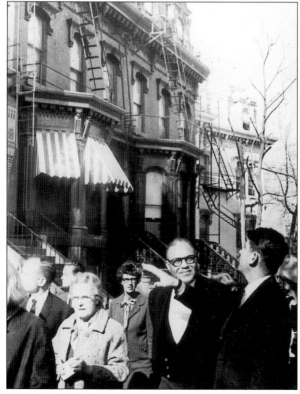

NCPC architect Don Jackson leads the group along Vermont Avenue south of the Circle in 1964. (Courtesy Washingtoniana Division, MLK Jr. Public Library.)

41

NCPC architect Steve Kloss participated in the 1964 NCPC tour to explain the reasons for saving the buildings surrounding Logan Circle. (Courtesy Washingtoniana Division, MLK Jr. Public Library.)

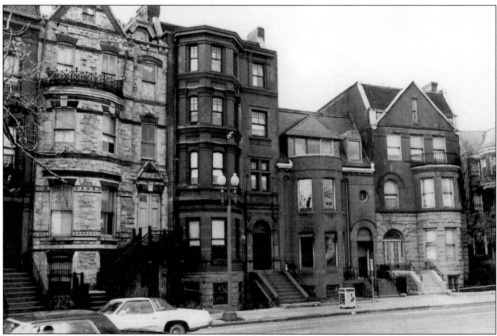

Several photographs of the homes surrounding Logan Circle, including this one, appeared in the *Washington Star* edition of January 14, 1975 and showed the conditions of the architecture at the time. These were taken by photographer Pete Schmick. (Courtesy Washingtoniana Division, MLK Jr. Public Library.)

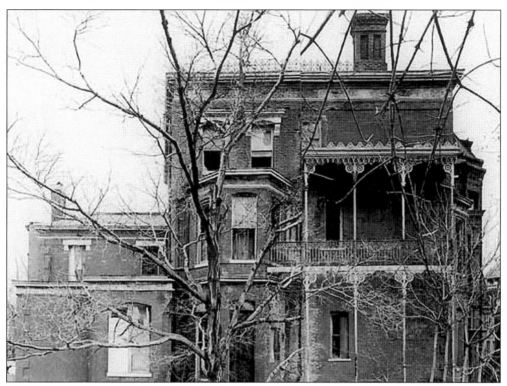

The house at 4 Logan Circle was documented in 1973 in a dilapidated condition for the Historic American Buildings Survey. (Courtesy Prints and Photographs Division, Library of Congress.)

The *Washington Star* reported in its December 19, 1974 issue that on "Sunday, this once splendid manse at 4 Logan Circle began to crumble. Police blocked traffic, city officials rushed over to inspect and nothing was done. Preservation minded residents of the circle—declared an historic district by the city in 1971, maintain the city can immediately repair the house, then bill the owner. The city concurs, but doubts the 'Immediately' aspect. Meanwhile inspectors said number 4 may end the debate by just falling down." The house remains one of the most gracious structures on the Circle today. (Courtesy Washingtoniana Division, MLK Jr. Public Library.)

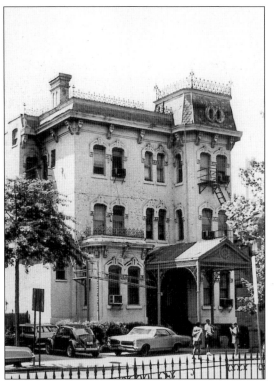

The house at Thirteenth Street and Logan Circle was photographed for the *Washington Daily News* on May 25, 1970 when it served as a rooming house, a common use for many of the large, formerly single-family homes. (Courtesy Washingtoniana Division, MLK Jr. Public Library.)

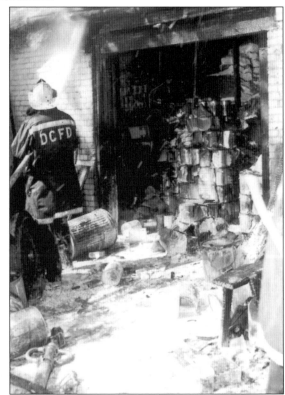

A hazardous fire was extinguished at a hardware store located in the 1400 block of P Street, pictured here in the *Washington Daily News* edition of October 2, 1957. (Courtesy Washingtoniana Division, MLK Jr. Public Library.)

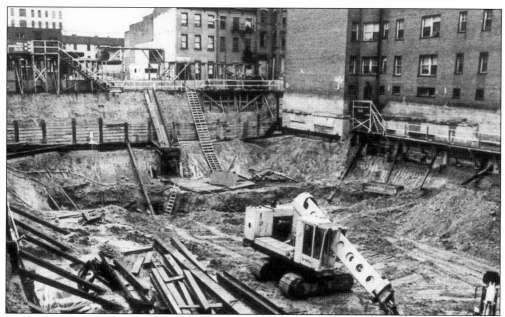

This November 4, 1980 image shows the construction site for a large building just south of Logan Circle, at the corner of Thirteenth and N Street. If the Circle itself had not been designated a local historic district in 1971, it would have most likely met the fate of Thomas and Scott Circles, which are today surrounded with large office buildings and hotels. This image was taken by John M. Taylor for the *Washington Star*. (Courtesy Washingtoniana Division, MLK Jr. Public Library.)

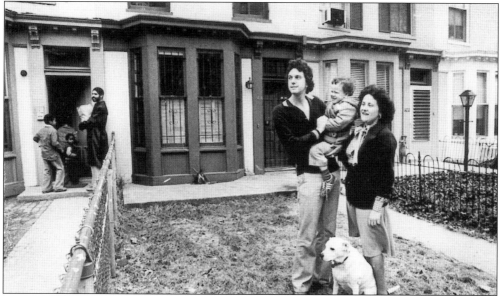

Renovation efforts over the years have been documented by local newspapers; one such example is this Bob Grieser photograph of the Clopton family—Mark, Aaron, Anna, and their dog Terry—standing in front of their renovated house in the 1400 block of Fourteenth Street, NW. The image appeared in the *Washington Star* on March 25, 1978. (Courtesy Washingtoniana Division, MLK Jr. Public Library.)

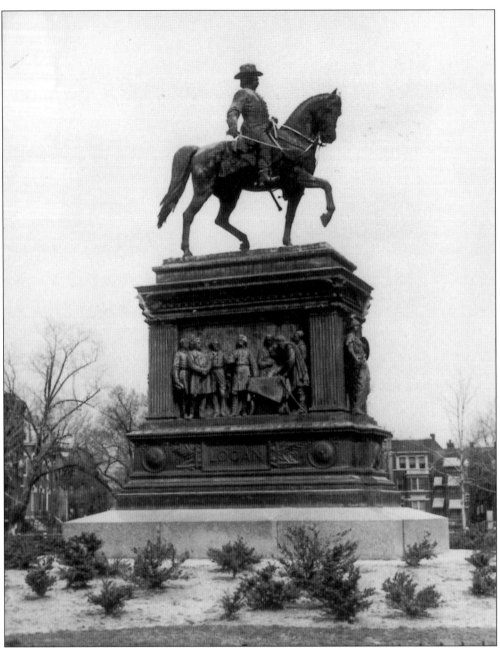

A witness to dramatic changes over the past 100 years, the Logan statue was pictured in the *Washington Star* on March 30, 1955, unclean and surrounded with rather sparse landscaping in this photograph by Francis Routt. (Courtesy Washingtoniana Division, MLK Jr. Public Library.)

Two

THOMAS CIRCLE

Thomas Circle was also a part of the L'Enfant plan for Washington and was the site of small wood frame structures by the time the Civil War broke out. Located at the intersection of Vermont and Massachusetts Avenue, Fourteenth, and M Streets, Thomas Circle witnessed substantial housing construction by 1880. In 1869, Gen. Montgomery C. Meigs designed a grand house just north of the circle, while other Civil War veterans of varying ranks built impressive homes of more modest means. The Circle itself is named after Maj. Gen. George H. Thomas (1816–1870), whose statue was placed at the center in 1879.

A street railway with horse-drawn cars was installed around the Circle in the mid-1860s, opening up areas to the north for development. With city improvements in the early 1870s that brought paved roads and sewers to the area, the Circle environs blossomed into a tony area for Washington's wealthy and Congressmen from afar. Luther Place Memorial Church was built in 1874, and the first luxury apartment building in Washington, the Portland Flats, was built in 1879.

However, large homes were being converted to other uses as early as 1890, when Logan Circle was the prestigious area in which to reside. For instance, on Thomas Circle, the Crawford Hill House became the Norwood Institute, a school for "select young ladies."

The horse-drawn railway was replaced by the 1890s with a rail line, carrying commuters to newer sections of the city. As large mansions in the downtown core were slowly being demolished for larger buildings, the trend edged its way toward Thomas Circle. Many of the homes around the Circle survived until the 1940s but were eventually replaced by large hotels and office buildings.

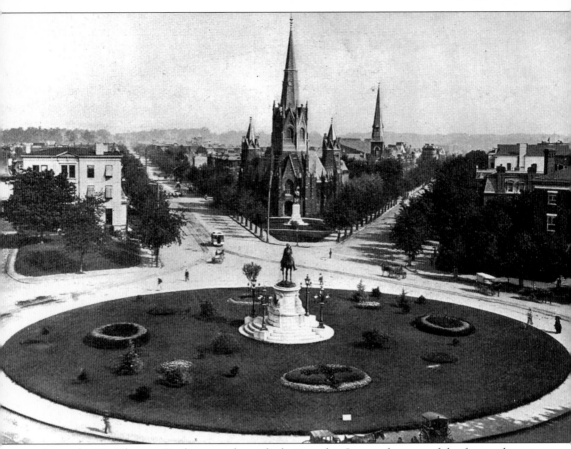

Around 1900, Thomas Circle was a place of relative calm. It served as one of the first and most prestigious areas in which the city's wealthy were to build fine homes, such as the Wylie Mansion visible on the right. (Courtesy Prints and Photographs Division, Library of Congress.)

On November 19, 1879, electric lights were demonstrated when the General Thomas statue was unveiled at Thomas Circle. Interestingly, power was brought to Fourteenth Street and Massachusetts Avenue from a Thirteenth Street sawmill. (Courtesy Washingtoniana Division, MLK Jr. Public Library.)

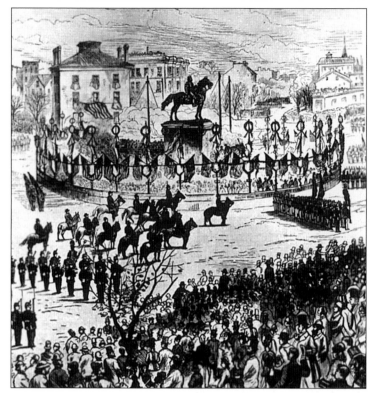

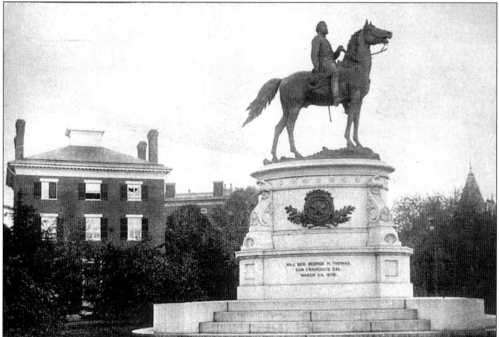

This 1894 view of Thomas Circle shows the proximity of the Judge Wiley residence to the Scott statue, setting the tone for what was then an exclusive residential neighborhood. (Courtesy Washingtoniana Division, MLK Jr. Public Library.)

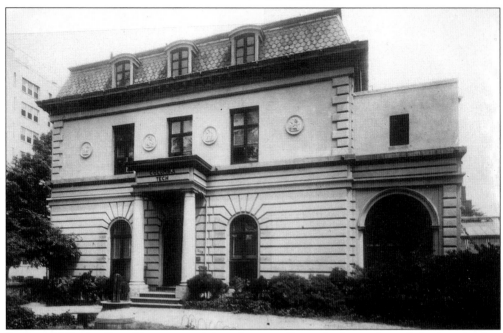

Built in 1869, the Gen. Montgomery Meigs house at Scott Circle is acknowledged as the first mansion in Washington to be designed in the rusticated Italian Renaissance style. Meigs designed his own home, which stood at 1239 Vermont Avenue (at N) until it was torn down in 1962 for an apartment building. Meigs designed the aqueduct system for Washington, sketched various scenes in the city, and was an active architect on many governmental buildings. (Courtesy Washingtoniana Division, MLK Jr. Public Library.)

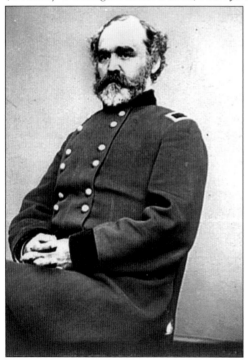

This portrait of Renaissance man Montgomery C. Meigs (1816–1892) was taken by famed Civil War photographer Matthew Brady between 1860 and 1865. (Courtesy Prints and Photographs Division, Library of Congress.)

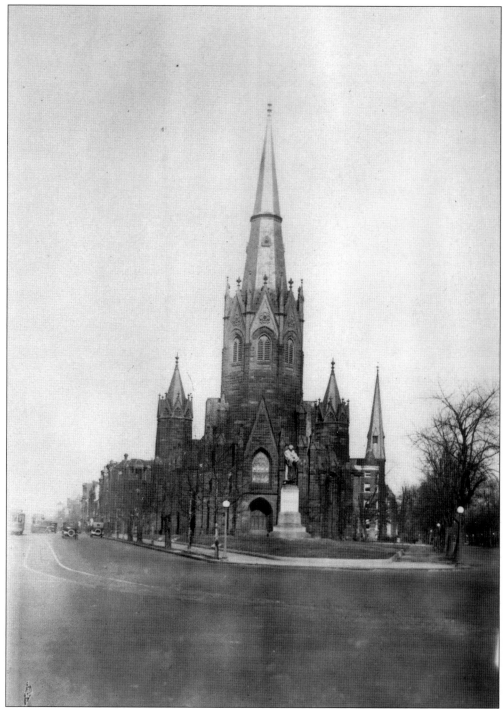

The Luther Place Memorial Church at 1226 Vermont Avenue is pictured here in a moment of solitude without any traffic around Thomas Circle. The Martin Luther statue is a replica of one created by E. Reitschel and was installed in 1884. (Courtesy Prints and Photographs Division, Library of Congress.)

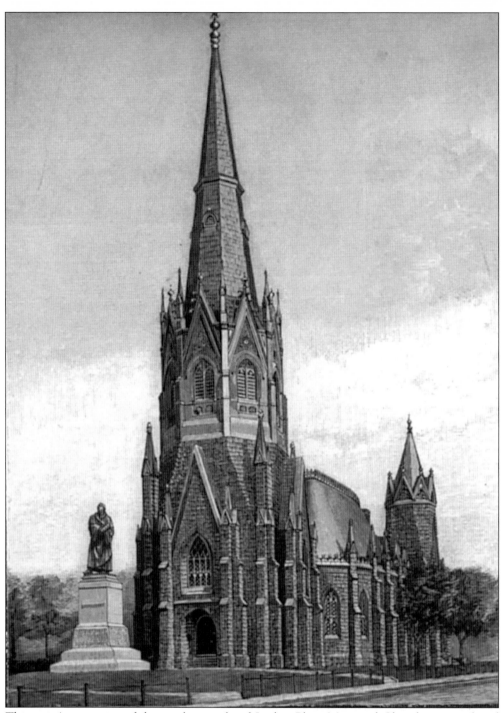

This artist's engraving of the newly completed Luther Place Memorial Church was produced about 1875. (Courtesy Washingtoniana Division, MLK Jr. Public Library.)

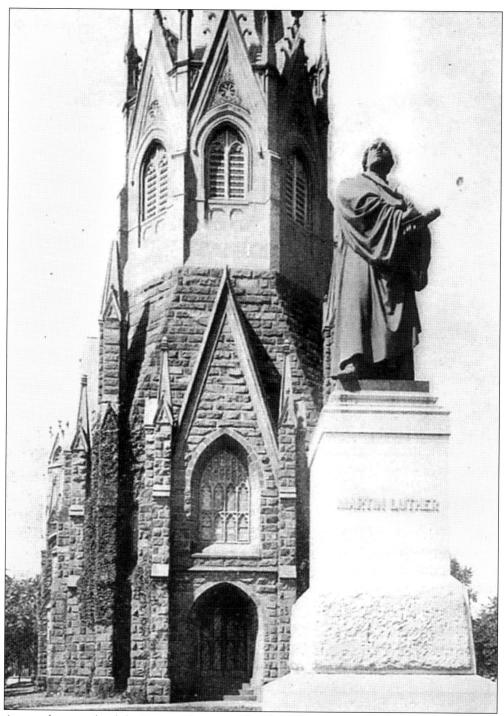

A rare photograph of the Luther Memorial Church and the Martin Luther statue at Thomas Circle appeared in the book *Everyday Life in Washington*. The author credited the building as being "to my mind, one of the most impressive church structures in this city of churches." (Author's collection.)

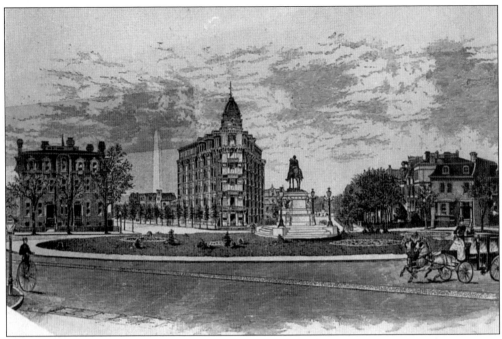

The Portland Flats apartment building, seen in this 1885 engraving, was an immediate success. In 1883, the *Cleveland Leader* stated, "The Portland Flats, where the Russian Minister and many other prominent people live, have been a paying investment." The article's author also noted that several other apartment buildings were then being built and that the city would be full of such buildings in a short ten years. (Author's collection.)

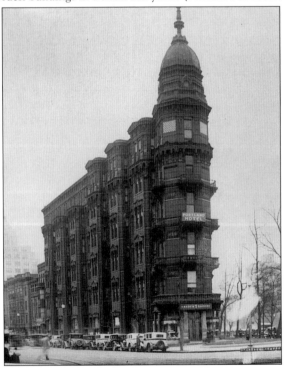

The Portland Flats building appeared in *Rider's Washington: A Guidebook* in 1924, when it was known as the Portland Hotel. Built in 1879, its official address was 1114–1136 Fourteenth Street. (Courtesy Washingtoniana Division, MLK Jr. Public Library.)

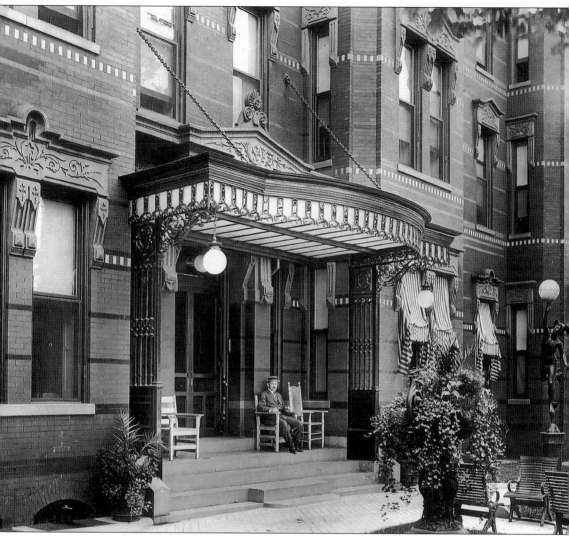

This elegant cast-iron entrance canopy was added to the Portland Flats about 1905. It was manufactured and installed by Frederick Gichner, owner of the Gichner Iron Works, who was photographed seated under his proud commission. (Courtesy Historical Society of Washington.)

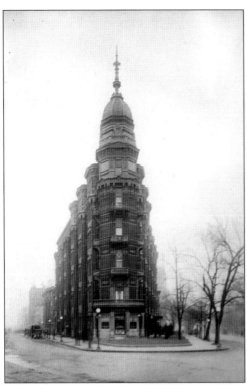

The elegant and refined Portland Flats apartment building was one of the first apartment houses to be built in Washington when it was completed in 1879. It was designed by architect Adolph Cluss at the point of Fourteenth Street and Vermont Avenue on the south side of Thomas Circle. It was razed less than 100 years later, in 1962. (Courtesy Prints and Photographs Division, Library of Congress.)

This rare photograph of the ground floor of the Portland Flats building was taken in 1927 as part of a project of the National Park Service, which needed to document each of its hundreds of "reservations" throughout the city, often small parcels located at intersections. This one is numbered 161. (Courtesy Prints and Photographs Division, Library of Congress.)

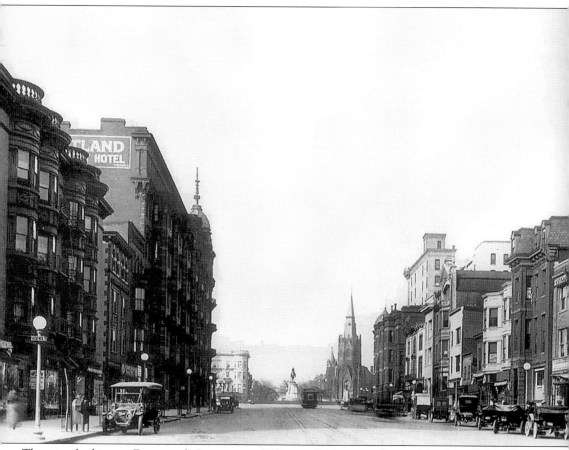

This view looking up Fourteenth Street toward Thomas Circle was taken on March 5, 1913 and shows an advertising sign on the side of the Portland building on the left. Built in 1879, Portland Flats was demolished in 1962 to make way for an office building that was constructed four years later. At the time, Fourteenth Street was composed of a series of low commercial buildings with apartments located above the retail ground floor. (Courtesy National Archives.)

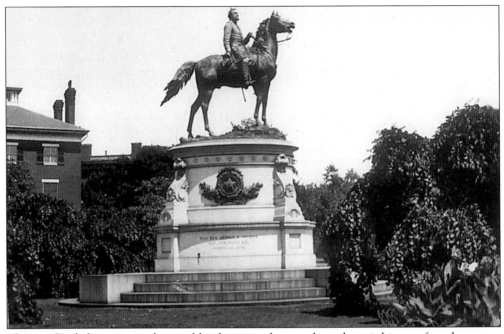

Thomas Circle has witnessed several landscaping changes throughout it history, from bare grass to lush and large foliage as seen here about 1940. (Courtesy Washingtoniana Division, MLK Jr. Public Library.)

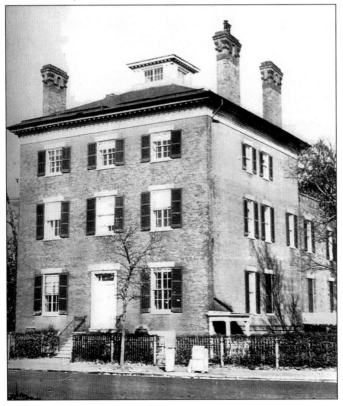

The original owner and builder of this house, known as the Wylie Mansion, was actually Charles L. Coltman (1800–1862), an early brick maker and builder in Washington. The Wylie name stuck when a later owner, Judge Andrew Wylie, occupied the house and was responsible for the sensational trial surrounding the Lincoln assassination conspirators. (Courtesy Historical Society of Washington.)

These gentlemen were photographed in front of the Wylie House on Thomas Circle about 1920. The house, believed to have been built in 1843, was demolished in 1947. (Courtesy Historical Society of Washington.)

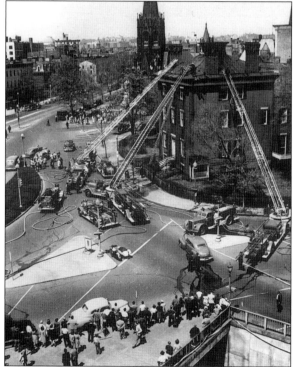

On April 20, 1947, the *Washington Star* ran this photograph of a fire at the Wylie Mansion on Thomas Circle that spelled the demise of the structure, which was torn down a short time later. (Courtesy Washingtoniana Division, MLK Jr. Public Library.)

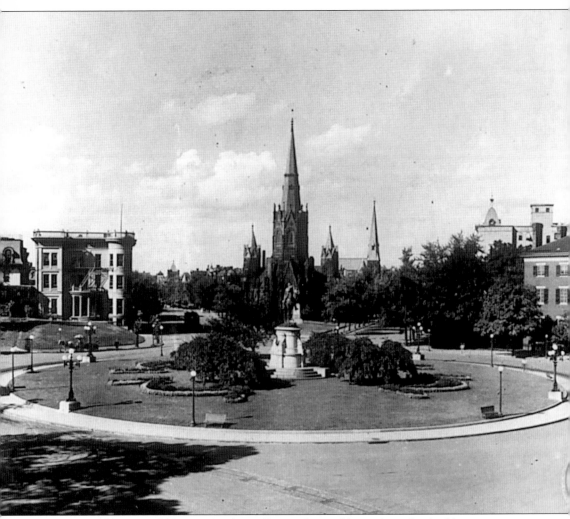

In this 1925 image of Thomas Circle, trolley tracks, visible on the right, had been in existence for about 25 years, but the streetlamps surrounding the Circle had replaced gas lamps just two years prior, in 1923. (Courtesy Prints and Photographs Division, Library of Congress.)

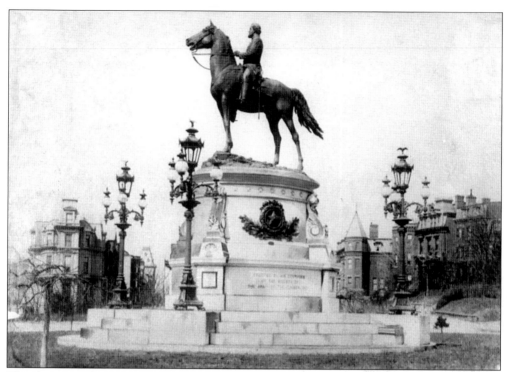

The elegant gas lamps at the base of the Thomas statue were photographed before they were removed. (Courtesy Prints and Photographs Division, Library of Congress.)

The gas streetlamps that were located along Thomas Circle as early as 1880, such as this one at Massachusetts Avenue and Fourteenth Street, were removed from service and destroyed in 1923. The City of Washington first converted from oil to gas streetlamps in 1848, and by the time the Civil War erupted, more than 800 public gas lamps were in operation throughout the city. (Courtesy Smithsonian Institution.)

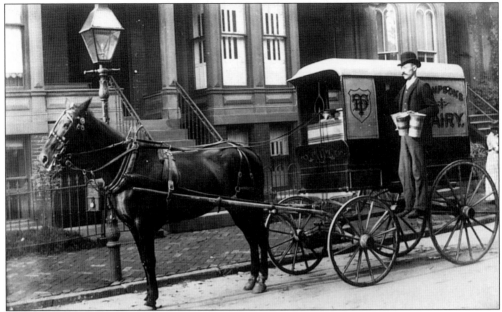

Many Thomas Circle residents received their milk delivery from John S. Thompson, the founder of Thompson's Dairy, which was established at Eleventh and U Street in 1881. Thompson's distributed ten gallons of milk a day back when it was delivered in raw form right from the delivery wagon. Pasteurization was not required until 1925. (Courtesy Washingtoniana Division, MLK Jr. Public Library.)

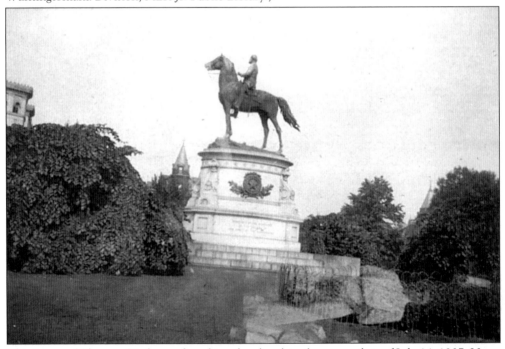

This image of Thomas Circle was found in a local archive bearing a date of July 14, 1907. Upon closer inspection, a double exposure of a Victorian woman can be seen in the grassy area of the photograph. (Courtesy Washingtoniana Division, MLK Public Library.)

This elegant house was typical of those that stood around Thomas Circle for many decades before being torn down to make way for the office buildings and hotels that surround the site today. This home was located at 1421 Massachusetts Avenue, and the living room photograph below offers a rare insight into the eclectic design tastes of the period. (Both courtesy Washingtoniana Division, MLK Jr. Public Library.)

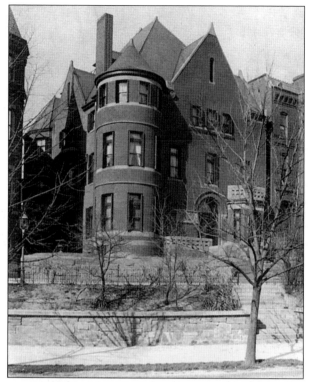

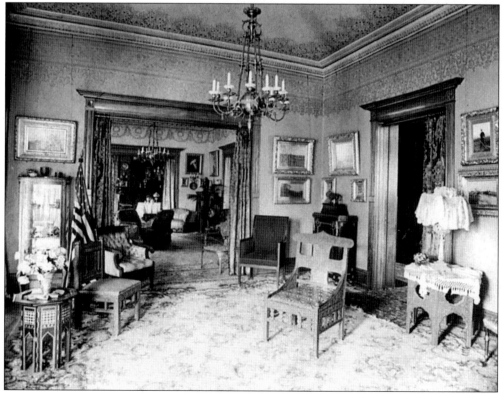

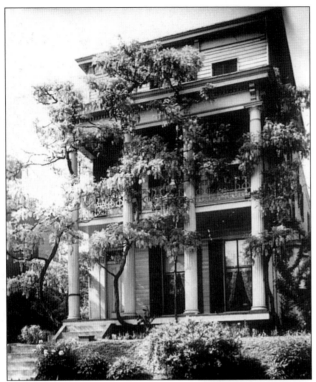

Known as the Wisteria House for obvious reasons, the elegant columned mansion that once stood at the northwest corner of Massachusetts Avenue and Eleventh Street was torn down in 1924. It had been built in 1863 for hardware merchant William Thomas. The massive wisteria was brought from China as a gift from a naval officer. (Both courtesy Washingtoniana Division, MLK Jr. Public Library.)

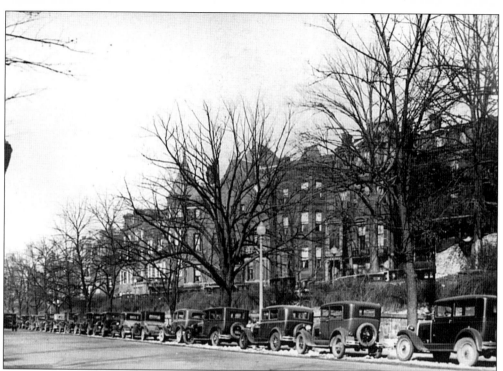

This fine row of homes that once lined "Massachusetts Avenue Terrace" on the north side of Massachusetts Avenue between Fourteenth and Fifteenth Streets was photographed on December 1929. The Christian City Church and several apartment buildings replaced these buildings in the following decades. (Courtesy Washingtoniana Division, MLK Jr. Public Library.)

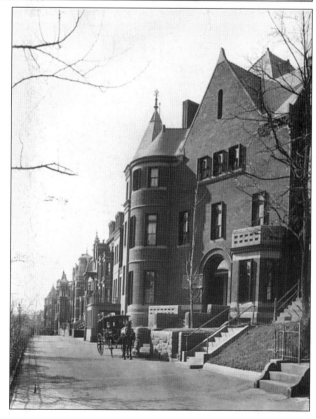

The house at 1421 Massachusetts Avenue on the Terrace was photographed about 1900, including the following series of rare interior views that show the variety of decorating techniques popular at the time. (Courtesy Washingtoniana Division, MLK Jr. Public Library.)

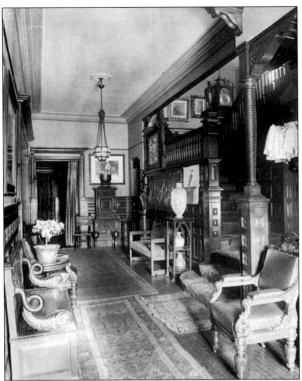

This is the entrance hall at 1421 Massachusetts Avenue. The chairs at the right were once used in the U.S. House of Representatives. (Courtesy Washingtoniana Division, MLK Jr. Public Library.)

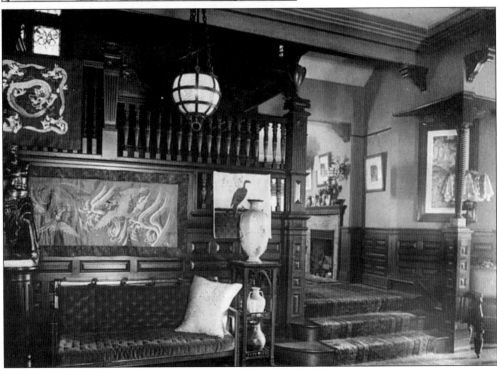

The hall and stairway are seen here from the rear drawing rooms at 1421 Massachusetts Avenue. (Courtesy Washingtoniana Division, MLK Jr. Public Library.)

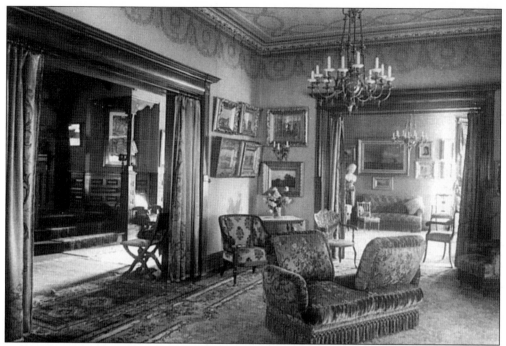

This view looks from the rear drawing room to the front drawing room of 1421 Massachusetts Avenue. (Courtesy Washingtoniana Division, MLK Jr. Public Library.)

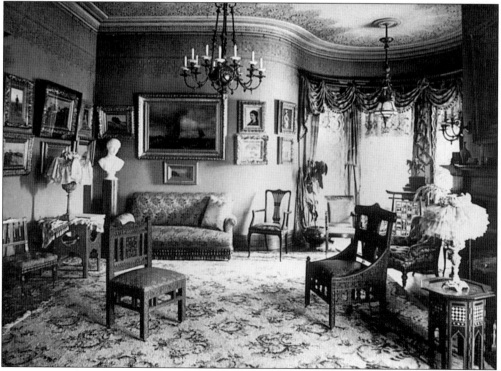

Here is the front drawing room, looking south, at 1421 Massachusetts Avenue. (Courtesy Washingtoniana Division, MLK Jr. Public Library.)

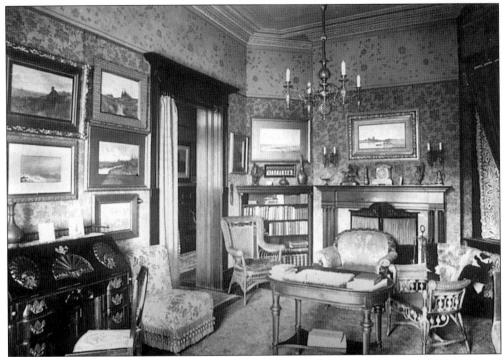

The reception room of 1421 Massachusetts Avenue appears above. (Courtesy Washingtoniana Division, MLK Jr. Public Library.)

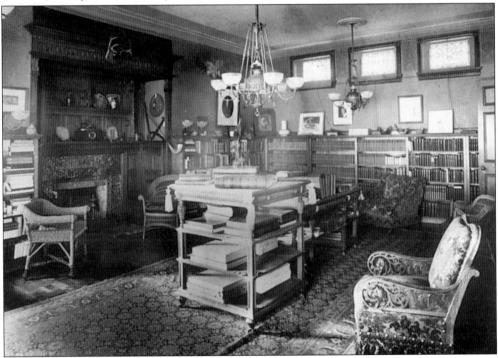

The library at 1421 Massachusetts Avenue was captured in this view looking northeast. (Courtesy Washingtoniana Division, MLK Jr. Public Library.)

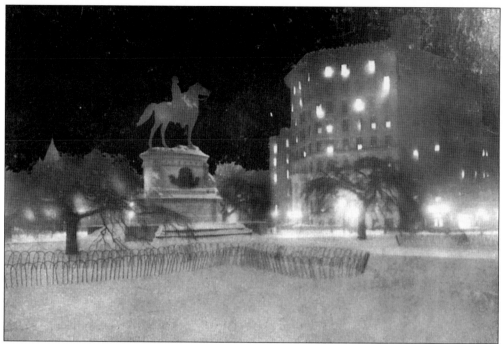

This nighttime winter scene of Thomas Circle was photographed in 1918. (Courtesy Washingtoniana Division, MLK Jr. Public Library.)

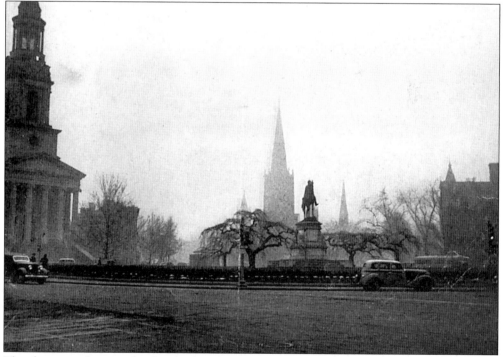

This dramatic photograph taken by Marjorie Barrows depicts Thomas Circle in the fog and first appeared in *Mayflower's Log Magazine* in December 1936. (Courtesy Washingtoniana Division, MLK Jr. Public Library.)

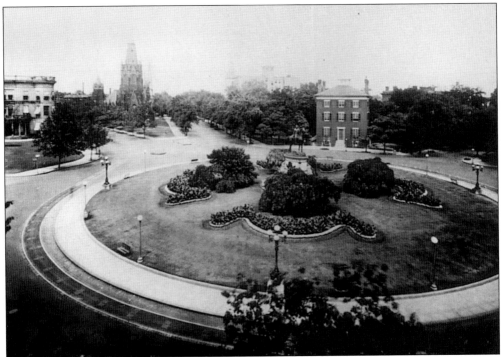

This picture of the sculpted gardens and Wiley residence on Thomas Circle was taken by an unknown photographer, facing north, on December 20, 1929. (Courtesy Washingtoniana Division, MLK Jr. Public Library.)

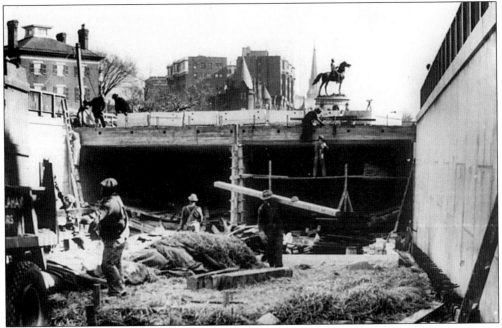

The Wiley residence and Victorian homes along Massachusetts Avenue are still seen in this January 23, 1940 photograph, taken during the construction phase of the Fourteenth Street underpass project. (Courtesy Washingtoniana Division, MLK Jr. Public Library.)

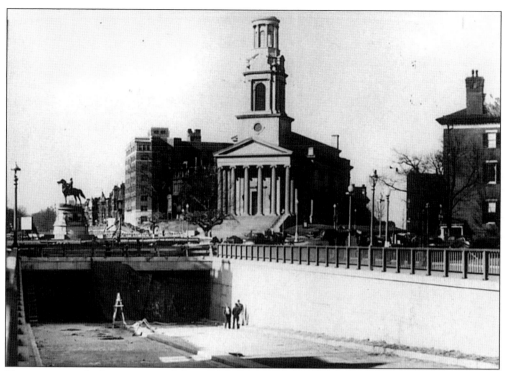

Not yet opened, the progress of the underpass construction for Massachusetts Avenue below Thomas Circle was captured on film on January 24, 1940. (Courtesy Washingtoniana Division, MLK Jr. Public Library.)

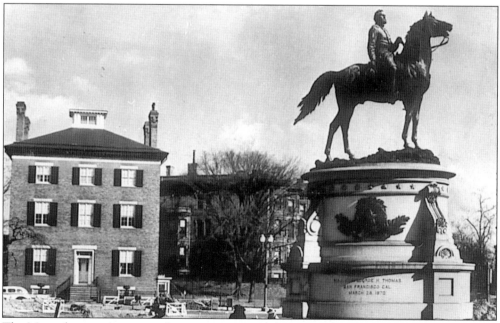

The Massachusetts Avenue underpass necessitated the removal and eventual relocation of the Thomas statue within the Circle as documented in this January 25, 1939 photograph from the *Washington Star*. (Courtesy Washingtoniana Division, MLK Jr. Public Library.)

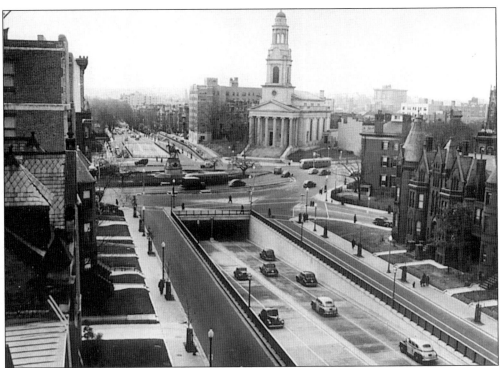

Massachusetts Avenue at Thomas Circle was still lined with the elegant homes of wealthy residents at the time this photograph was taken of the newly completed Massachusetts Avenue underpass, just prior to April 1940. (Courtesy Washingtoniana Division, MLK Jr. Public Library.)

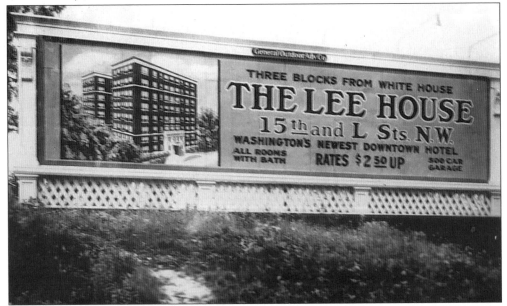

A billboard for the Lee House Hotel near Thomas Circle was placed in suburban Washington, capitalizing on the many new automobile travelers heading to the city following World War II. (Courtesy Washingtoniana Division, MLK Jr. Public Library.)

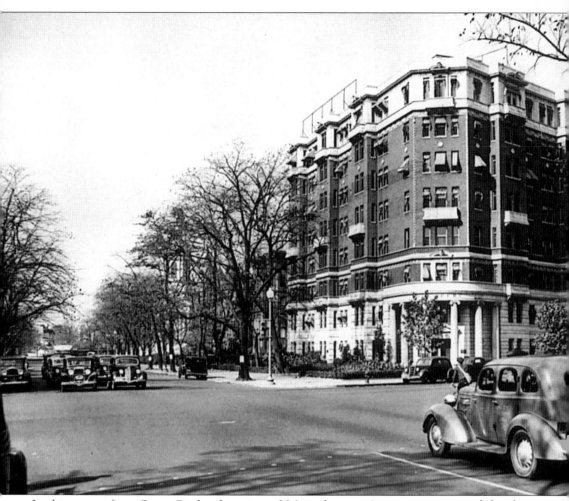

Looking west from Scott Circle, this view of Massachusetts Avenue was captured for the *Washington Star* by a photographer named Wilkinson on October 29, 1936. The elegant Belvedere apartment is located on the right. (Courtesy Washingtoniana Division, MLK Jr. Public Library.)

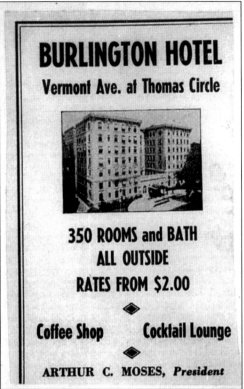

BURLINGTON HOTEL

Vermont Ave. at Thomas Circle

350 ROOMS and BATH
ALL OUTSIDE
RATES FROM $2.00

◆

Coffee Shop Cocktail Lounge

◆

ARTHUR C. MOSES, President

This early yet undated advertisement for the Burlington Hotel, which once existed on Vermont Avenue at Thomas Circle, offered room rates of $2 per night for most of its 350 rooms *and* 350 baths. (Courtesy Washingtoniana Division, MLK Jr. Public Library.)

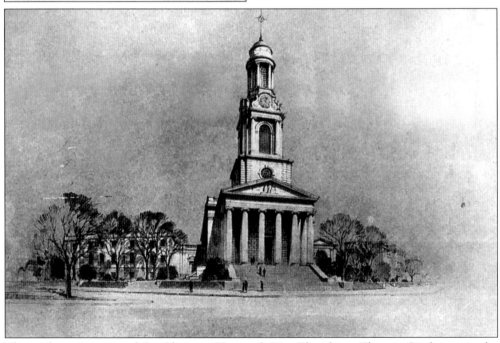

This architect's vision of the Christian National City Church on Thomas Circle ran in the November 1937 issue of the popular magazine coined *Pencil Points*. (Courtesy Washingtoniana Division, MLK Jr. Public Library.)

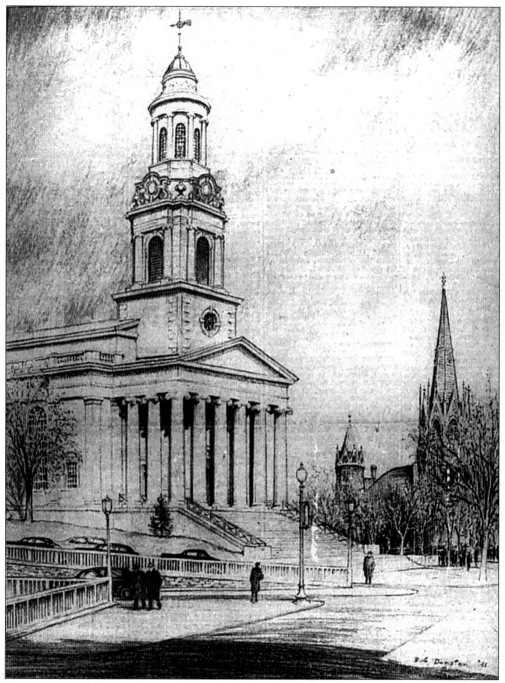

Shown upon its completion in the spring of 1941, the Christian National City Church has since dominated the western side of Thomas Circle. (Courtesy Washingtoniana Division, MLK Jr. Public Library.)

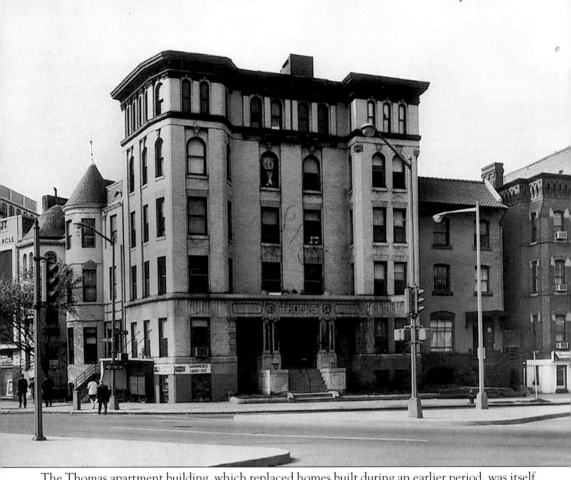

The Thomas apartment building, which replaced homes built during an earlier period, was itself torn down shortly after this photograph was taken in April 1970. The building once stood at 4 Thomas Circle. (Courtesy Prints and Photographs Division, Library of Congress.)

The residential nature of Thomas Circle remained mixed with commercial use until the 1970s, when these homes at 2–3 Thomas Circle were photographed as part of the Historic American Buildings Survey by photographer Thomas Smalling. The photograph below depicts the house at 5 Thomas Circle at the same time. All three were subsequently torn down. (Courtesy Prints and Photographs Division, Library of Congress.)

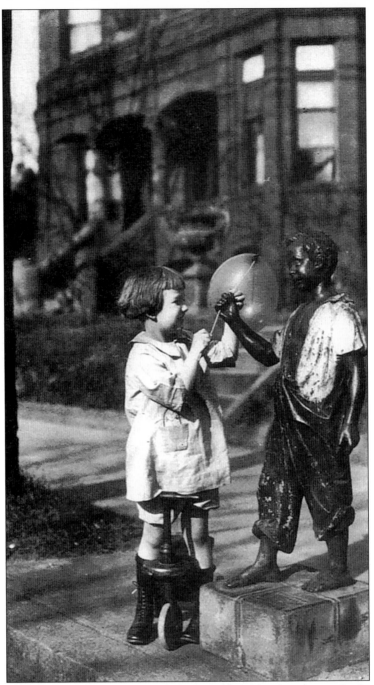

Like all cities at the time, Washington had a variety of hitching posts for horses located throughout the city. What would be considered disturbing today, this post depicting a slave boy mounted on a block of stone once stood between Scott and Thomas Circles along Massachusetts Avenue. It was photographed in 1923. Like many wrought-iron balconies, fences, and street furniture, the hitching post was likely removed and used for scrap to aid in the World War II effort. (Courtesy Smithsonian Institution.)

This small office building at 1151 Sixteenth Street, just south of Scott Circle, was pictured in the *Washington Star*'s July 6, 1947 edition just prior to the structure's demolition. It had been occupied for the prior 44 years by William King & Sons, Washington's oldest coal firm. The business moved its offices to its coal yard at 2901 K Street, having been established there since 1835. (Courtesy Washingtoniana Division, MLK Jr. Public Library.)

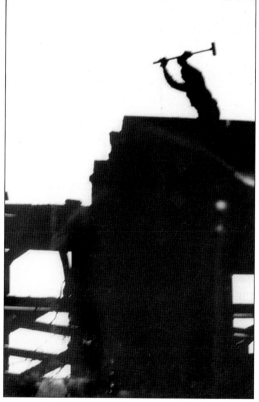

This silhouetted image of the demolition of the Cumberland Apartment building on Thomas Circle ran in the *Washington Star* on February 16, 1968. The photograph was taken by Wally McNamee. (Courtesy Washingtoniana Division, MLK Jr. Public Library.)

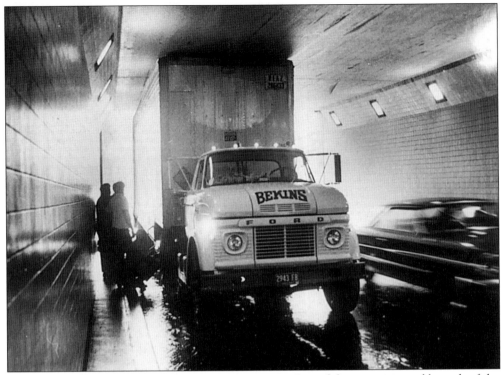

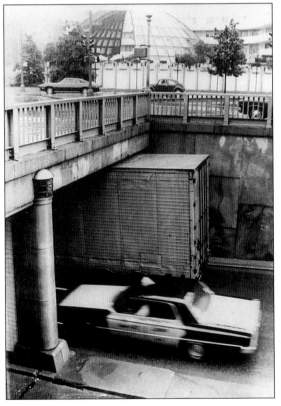

One of the unanticipated hazards of the underpass running beneath Thomas Circle, discovered years after its completion, was its height. An unfortunate Bekins moving truck made an appearance in the August 26, 1971 issue of the *Washington Star* when it became wedged into the low underpass while headed north. The swimming pool dome of the International Inn is visible at the top of picture taken by a photographer named Beall. (Both Courtesy Washingtoniana Division, MLK Jr. Public Library.).

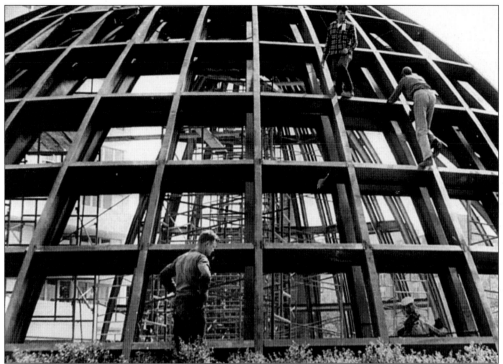

Workers are seen here completing the dramatic dome that was built over the front swimming pool at the International Inn on Thomas Circle. Both the hotel, now renamed the Washington Plaza, and the pool remain today, albeit without the domed pool enclosure. This picture first ran in the *Washington Post* on October 11, 1962. (Courtesy Washingtoniana Division, MLK Jr. Public Library.)

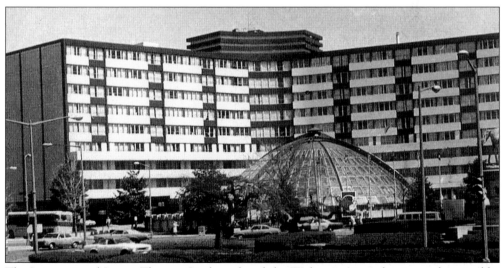

The International Inn at Thomas Circle replaced the Wylie mansion after it was destroyed by fire and represented, at the time, a modernistic approach to urban hotel living, with a domed swimming pool at its center. (Courtesy Smithsonian Institution.)

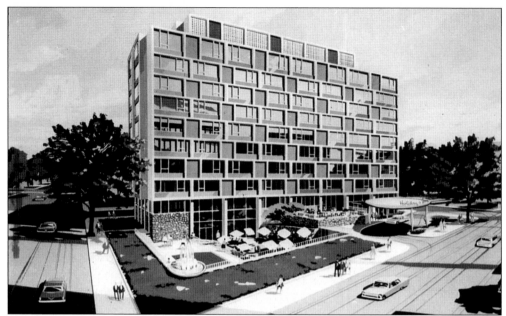

Construction of the "modern" Rhode Island Avenue Holiday Inn on Seventeenth Street and Scott Circle was begun in November 1962 to the design specifications of Edwin Weihe and Associates, Architects. The hotel was built at a cost of $2.5 million and included 8 stories housing 161 rooms. (Courtesy Washingtoniana Division, MLK Jr. Public Library.)

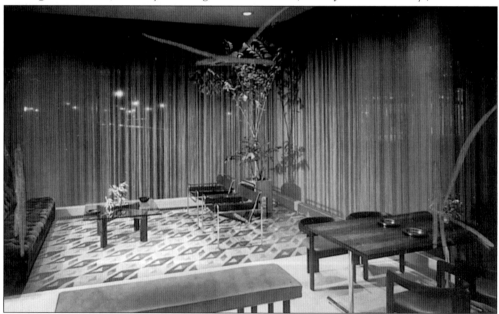

This interior photograph of the lobby of the Holiday Inn at Scott Circle appeared in the April 3, 1964 edition of the *Washington Star*. It had been designed by Helen Millman to "utilize a small area in the most spacious appearing manner. The glass curtain filters light and gives a feeling of enclosure without a feeling of confinement. The chairs are reproductions of a design by Marcel Breuer, a pioneer modernist, in the early 1920s. Mrs. Millman designed the coffee table." (Courtesy Washingtoniana Division, MLK Jr. Public Library.)

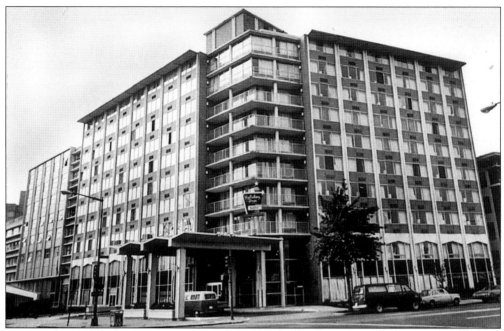

The original design of the Holiday Inn at Fifteenth and Rhode Island Avenue near Scott Circle differs from its modernized appearance today. The original hotel was depicted in this Ray Lustig photograph in the November 10, 1977 issue of the *Washington Star* after its completion. (Courtesy Washingtoniana Division, MLK Jr. Public Library.)

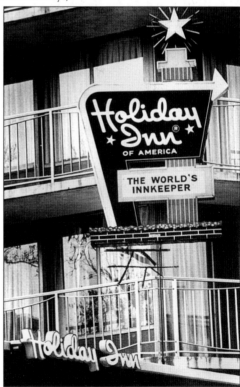

The Holiday Inn featured a miniaturized version of the famous Holiday Inn logo atop its entrance canopy at the corner intersection. (Courtesy Washingtoniana Division, MLK Jr. Public Library.)

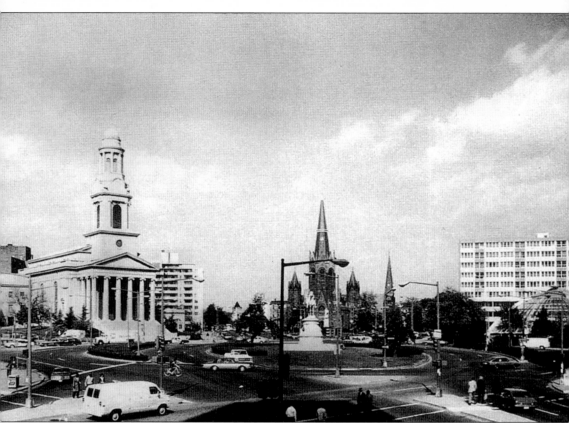

Taken by Charles Suddarth Kelly, this 1981 image of Thomas Circle shows, at right, the International Inn, which replaced the Wylie House, with its modern style that extends to the swimming pool enclosure. This building marked the transformation of Thomas Circle from a primary residential neighborhood to one defined by commercial, hotel, and office use.

Three

SCOTT CIRCLE

The development of Scott Circle closely relates to Thomas Circle, located only a few blocks to the east, in that both were considered to be on the edge of the City when first settled in the 1820s. Also included on L'Enfant's plan for the city, Scott Circle was eventually named for Civil War general Winfield Scott (1786–1866) when his statue was unveiled at its center in 1874. Scott Circle is located at the intersection of Rhode Island and Massachusetts Avenues and M and Sixteenth Streets. In this case, the introduction of the statue, itself, in the center of a relatively unoccupied circle prompted an interest in the area.

The first to build impressive mansions around the Circle in the 1870s were high-ranking government officials including the Secretary of the Treasury William Windom. Washington Post founder Stilson Hutchins built a mansion at 1603 Massachusetts Avenue in 1883 and later donated funds for the erection of the Daniel Webster statue that still stands on the west side of the circle.

Like Thomas Circle, development pressures encroaching from the south soon doomed all but one of the former mansions that lined the circle. These grand structures were demolished and soon replaced with hotels, office buildings, and apartment houses by the 1940s. One lone survivor, albeit remodeled, remains on the eastern portion of the Circle at Rhode Island Avenue. Built in 1879 for Alexander Graham Bell, the home was later owned and lived in by Vice President Levi P. Morton while serving in President Benjamin Harrison's administration.

Nos. 43-44.—Views at L and M streets, on Sixteenth street, April, 1900. By favor of Mr. L. C. Handy, photographer for departments, Washington, 1900.

Even several decades after the Civil War, much of Washington retained a small-town atmosphere, as these two April 1900 photographs, taken along Sixteenth Street between at L and M Streets, illustrate. This view was captured by L.C. Handy. (Courtesy Washingtoniana Division, MLK Jr. Public Library.)

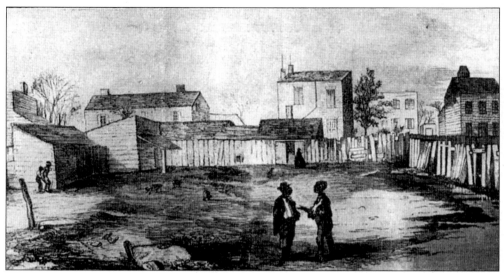

Appearing in the *Washington Star*'s April 1, 1934 edition was this sketch described as the "Rear view of houses on Fifteenth Street, between K and Massachusetts Avenue, in 1859." The image shows the rural nature of the area at the time. (Courtesy Washingtoniana Division, MLK Jr. Public Library.)

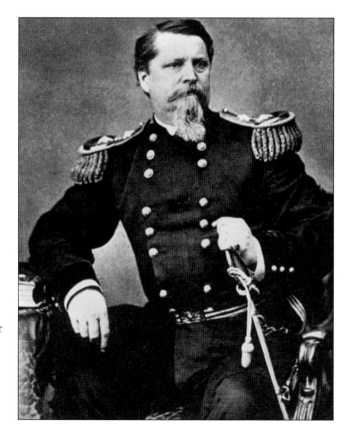

Noted Civil War photographer Mathew Brady made this image of Gen. Winfield Scott, the man for whom Scott Circle is named. (Courtesy Washingtoniana Division, MLK Jr. Public Library.)

The Scott statue, completed and unveiled in 1874, was designed by sculptor Henry Kirke Brown and architect Gen. O.E. Babcock. General Scott actually rode a mare into battle during the Civil War, but his family thought that the horse should be depicted as a stallion.

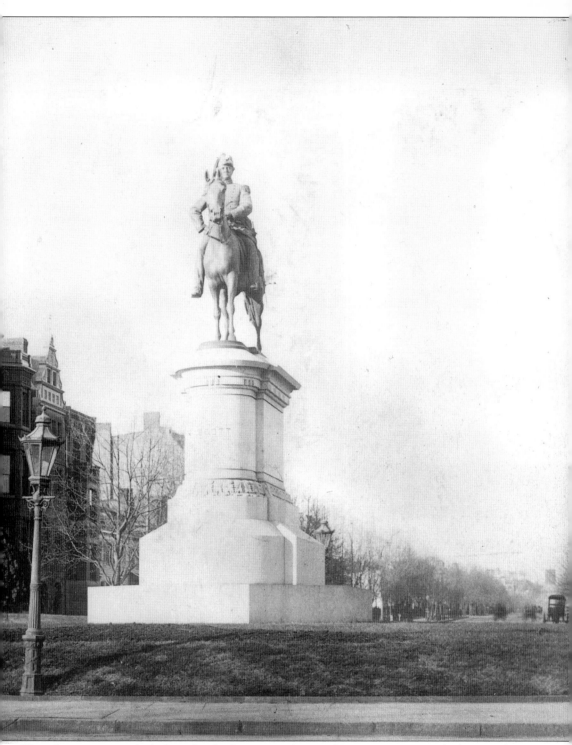

The change was made before the final cast was begun. (Courtesy Prints and Photographs Division, Library of Congress.)

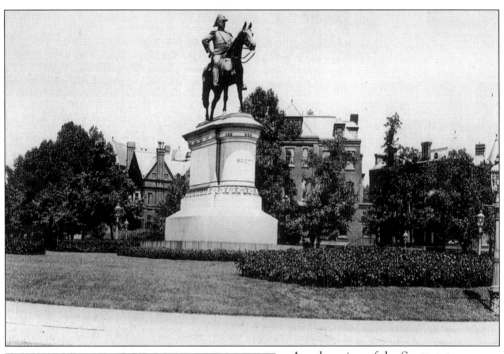

Another view of the Scott statue, looking north up Sixteenth Street about 1900, reveals additional insight into the lavish homes that once surrounded the Circle and its formal gardens. (Courtesy Historical Society of Washington.)

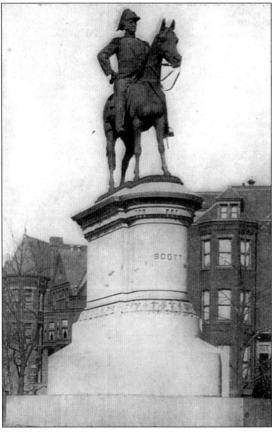

This close-up of the General Scott statue was first published in the book *Everyday Life in Washington* in 1900. Behind the statue are the homes that once lined the Circle, as well as Sixteenth Street to the north. (Author's collection.)

Alexander Graham Bell utilized this small frame house at 1234 Sixteenth Street as "The Bell Experimental School" for the deaf. He first rented the 1870 house in 1883, and it was located just south of Scott Circle, not far from where Bell himself resided for a short period of time, at 1500 Rhode Island Avenue. The school was later incorporated into the Volta Bureau on Fifteenth Street in Georgetown, and this house was torn down in 1920. (Courtesy Smithsonian Institution.)

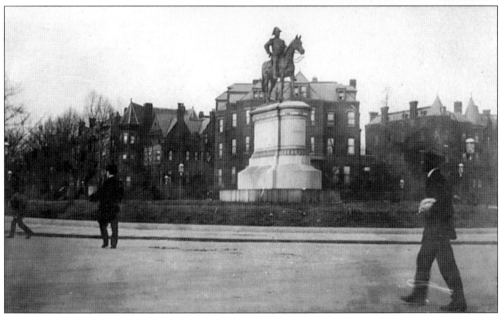

Massachusetts Avenue at Scott Circle, looking here toward Dupont Circle, was once heavily treed, a feature that is apparent in this June 1940 photograph. (Courtesy Washingtoniana Division, MLK Jr. Public Library.)

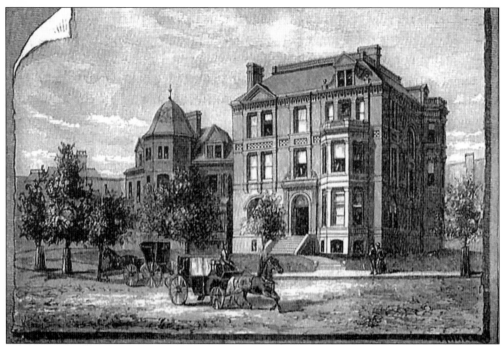

This house at 1601 Massachusetts Avenue, built for Secretary of the Treasury William Windom in 1881, stood at the northwest corner of Scott Circle until it was demolished in 1964 and replaced by the Australian Embassy building, located at the site today. It first appeared in the book *Picturesque Washington* in 1886. (Author's collection.)

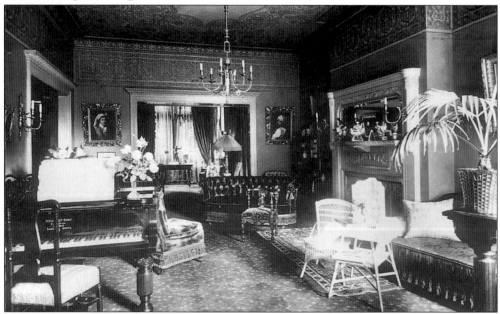

The Windom mansion's interior was pictured about 1888 with the typical Victorian decoration of the day, including wicker furniture, extensive layered wallpaper, and the favored palm plant. The house was designed by the firm of Dearing and Johnson. (Courtesy Smithsonian Institution.)

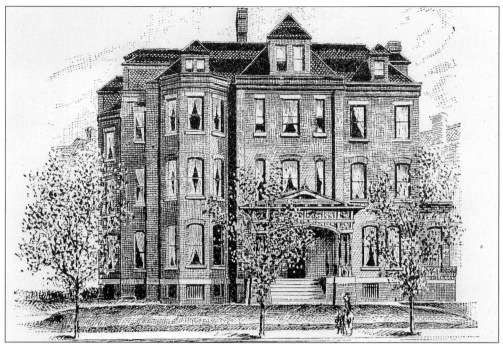

Once located between Rhode Island and Sixteenth Street at Scott Circle was the Cameron mansion, built in 1880 for James "Don" Cameron, a senator from Pennsylvania. (Courtesy Washingtoniana Division, MLK Jr. Public Library.)

This photograph of Scott Circle in 1907 illustrates the initial residential nature of the park, then surrounded by lavish homes. (Courtesy Washingtoniana Division, MLK Jr. Public Library.)

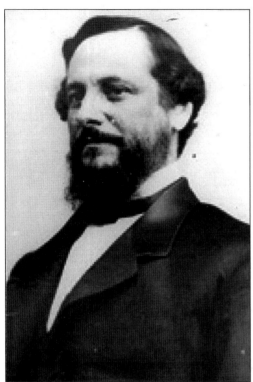

George Pendleton, pictured here when he served as a senator from Ohio, was one of the few Democrats that served in Congress during the Civil War. His wife was the daughter of Francis Scott Key. Pendleton died in 1889 in Berlin while he was serving as the U.S. minister of Germany. (Courtesy Washingtoniana Division, MLK Jr. Public Library.)

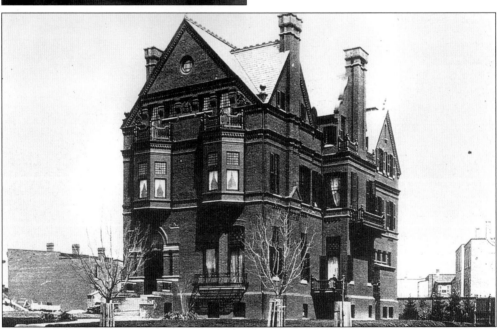

George H. Pendleton built this mansion at 1315 Sixteenth Street on Scott Circle in 1881. He had purchased the property from James Blaine, who decided to build a castle for himself on the then-vacant Dupont Circle. The house was torn down in the 1940s and replaced by the General Scott apartment building. (Courtesy Washingtoniana Division, MLK Jr. Public Library.)

One small memorial on Scott Circle honors the memory of Daniel Webster, seen here in a daguerreotype created between 1845 and 1849. Webster served as a Federalist congressman from New Hampshire (1813–1817), a Whig congressman from Massachusetts (1823–1827), a Whig senator from Massachusetts (1827–1841, 1845–1850), and secretary of state (1841–1843, 1850–1852). (Courtesy Prints and Photographs Division, Library of Congress.)

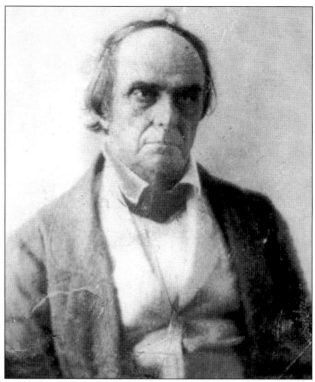

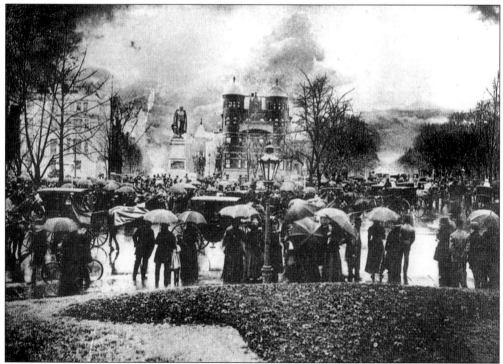

Taken on a wintry day in 1900, this photograph shows the unveiling ceremony of the statue of Daniel Webster just west of Scott Circle. (Courtesy Kiplinger Washington Collection.)

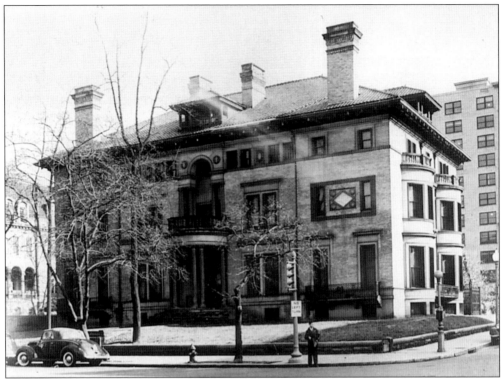

This large house, once located just south of Scott Circle at 1001 Sixteenth Street, was home to Senator Eugene Hale of Maine. Pictured on November 22, 1940 in the *Washington Evening Star* just before it was demolished, the home's reception room is pictured below. (Courtesy Washingtoniana Division, MLK Jr. Public Library.)

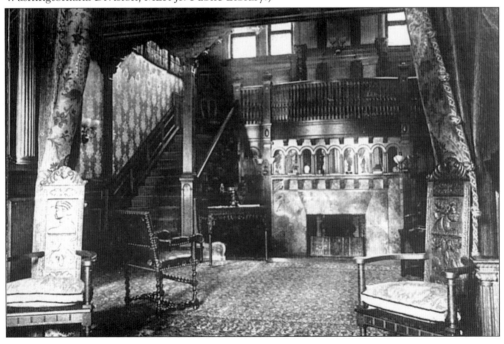

The home of Senator Eugene Hale of Maine, pictured here, was actually built and paid for by his father-in-law, Senator Zachariah Chandler of Michigan, and presented to him on the eve of his marriage to Senator Chandler's daughter Mary. (Author's collection.)

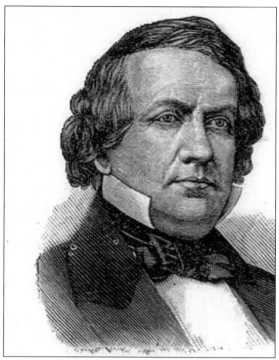

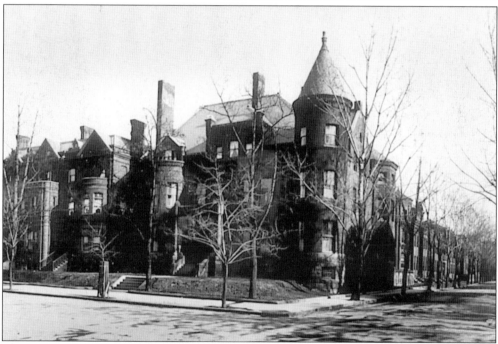

This impressive mansion at 1401 Sixteenth Street at the corner of O Street was built in 1888 for Susan Hart Shields. The widow of Civil War veteran William B. Shields, she had architect Samuel Edmonston design her house, which cost $40,000 to build. The 1500 block of O Street is visible to the right in this picture dated about 1900. (Courtesy Historical Society of Washington.)

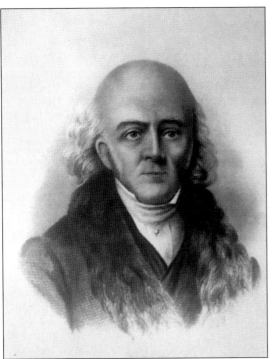

The Hahnemann statue at Scott Circle is dedicated to Samuel Hahnemann (1755–1843), a German physician who discovered the "law of similars," which states that diseases are cured by those drugs that produce similar symptoms when injected into healthy persons. This photograph was taken by Swormstedt & Babbitt. (Courtesy Prints and Photographs Division, Library of Congress.)

Spectators attended the Hahnemann statue unveiling and dedication at Scott Circle on an apparently hot day in 1900. The statue was designed by architect Julius F. Harden and sculptor Charles Henry Neihaus. (Courtesy Prints and Photographs Division, Library of Congress.)

Pictured here around 1925, the house that still exists today at 1500 Rhode Island Avenue at Scott Circle would not be recognizable to its first owner, who had the Victorian residence constructed in 1879. Built for John T. and Jessie Willis Brodhead and designed by architect John Fraser, the home was purchased in 1882 by Gardiner Hubbard for his daughter Mabel, who was married to Alexander Graham Bell. The structure would later undergo a dramatic architectural transformation. (Courtesy Washingtoniana Division, MLK Jr. Public Library.)

The building at 1500 Rhode Island was purchased by Levi P. Morton, the newly elected vice president, in 1889, and the Russian Embassy occupied it from 1903 to 1907. In 1912, Morton hired architect John Russell Pope to carry out a major renovation at a cost of $20,000. The Victorian bays, tower, and brick were removed and replaced with a limestone facade of Italian Renaissance design. This photograph taken by Theodor Horydczak, shows the home shortly after its renovation. (Courtesy Prints and Photographs Division, Library of Congress.).

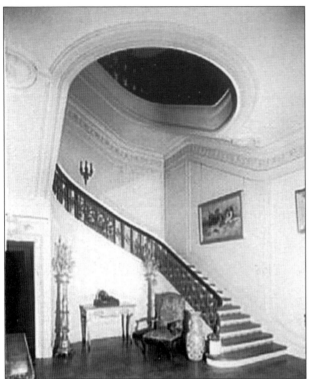

The interior of 1500 Rhode Island was also completely reconfigured and renovated in the 1912 project, which resulted in this dramatic staircase in its central hall. (Courtesy Prints and Photographs Division, Library of Congress.).

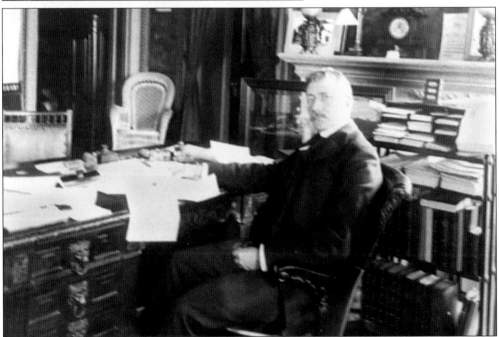

Elihu Root (1845–1937), seated here in his office, lived at 1500 Rhode Island Avenue from 1907 to 1909, when he held the office of secretary of state. The house was sold in 1939 to the National Paint, Varnish and Lacquer Association, which retains the house today. (Courtesy Prints and Photographs Division, Library of Congress.)

The Louise Home was founded by William W. Corcoran in 1871 for "impoverished gentlewomen who may need shelter of a friendly roof." Named for his deceased wife and daughter, the building was located on Massachusetts Avenue between Fifteenth and Sixteenth Streets, designed by Baltimore architect Edmund G. Lind, and built at a cost of $200,000. It was demolished in 1949. The home is illustrated above in an engraving dated 1887 and below in a photograph taken a short time later. (Above courtesy author's collection; below courtesy Historical Society of Washington.)

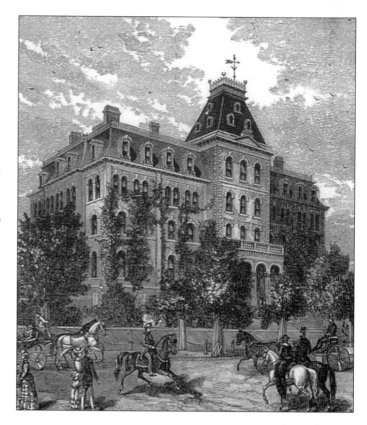

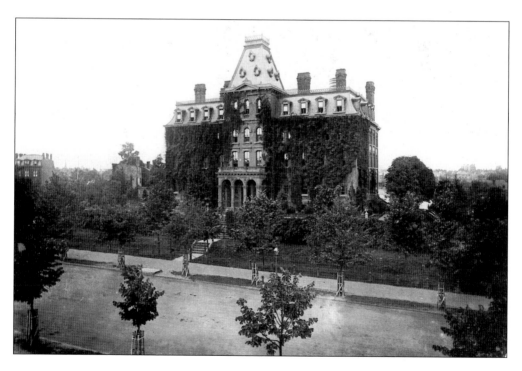

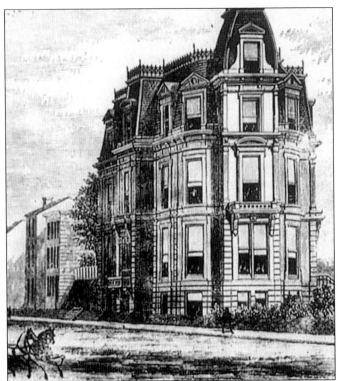

This image of 1402 Massachusetts Avenue was created about 1875, prior to the construction of a large addition at the corner by Mrs. Annie A. Cole. Originally designed and lived in by Peter J. Lauritzen around 1875, the home changed dramatically with the addition, which increased its size and altered its shape and architectural style. Once located at the intersection of M and Massachusetts Avenue, the structures were replaced in 1971, ironically, by the National Association of Home Builders office building. (Courtesy Historical Society of Washington.)

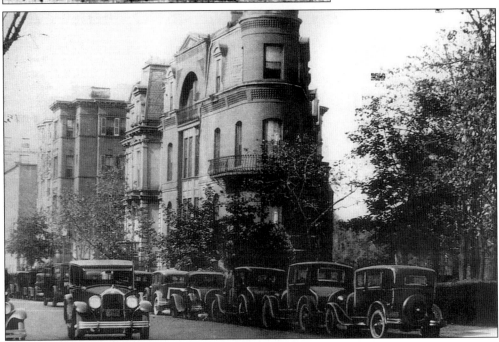

This c. 1928 view of the Cole residence at 1400–1402 Massachusetts Avenue depicts the house following the completion of the triangular, turreted corner addition that was commissioned by Cole, designed by noted architect Alfred B. Mullet, and completed in 1888. (Courtesy Historical Society of Washington.)

When the house at 1402 Massachusetts Avenue was photographed by Carl Mydans in November 1935, he noted that it was "once a fine old home, now a boarding house" and included it as part of a series of views showing blighted Washington completed for the Office of War Information. (Courtesy Prints and Photographs Division, Library of Congress.)

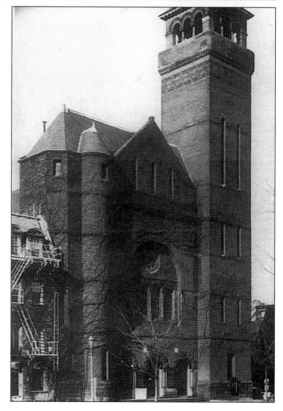

The tall tower often seen in the background of Scott Circle images to the north belonged to the First Baptist Church at the southwest corner of Sixteenth and O Street. It was designed by architect W. Bruce Gray and built in 1889. The congregation voted to demolish the structure in 1953 and replace it with the Gothic Revival structure present on the site today. (Courtesy Smithsonian Institution.)

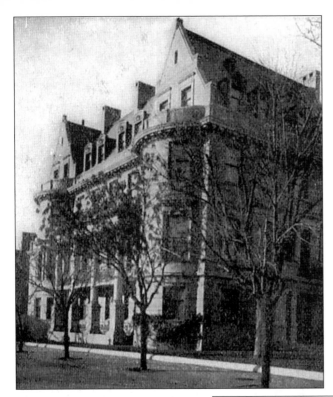

The exterior photograph the Foraker mansion at 1500 Sixteenth Street was included in the book *Everyday Life in Washington* in 1900. (Author's collection.)

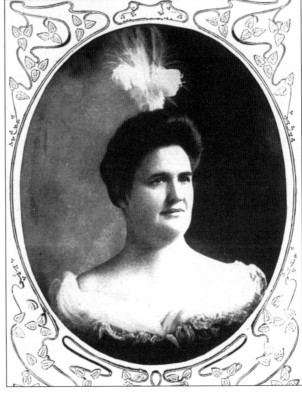

Scott Circle resident and senatorial wife Mrs. J.B. Foraker from Ohio was photographed at the time her family maintained homes both on Scott Circle at 1500 Sixteenth Street and in Cincinnati, Ohio, around the turn of the century. (Courtesy Washingtoniana Division, MLK Jr. Public Library.)

Senator J.B. Foraker and his son appeared in this photograph that was included in the book *Everyday Life in Washington* in 1900. (Author's collection.)

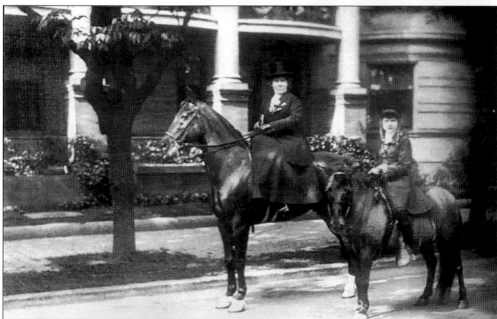

The Foraker Mansion was later occupied by Mrs. Delos (Daisy) Blodgett, the wealthy wife of a Michigan lumber businessman, who moved to Washington so her daughters could attend the city's prestigious boarding schools. Mrs. Blodgett is pictured here in front of the house with her daughter Mona. (Courtesy Historical Society of Washington.)

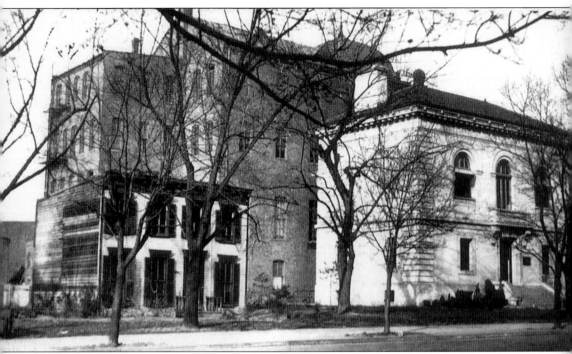

The origins of the relatively rural nature of the area surrounding Scott Circle can be seen in this 1907 photograph of the National Geographic Headquarters building, known as Hubbard Hall, with two small wood frame houses dating from before the Civil War. They were razed in 1913 for an addition to the facility designed by architect Arthur B. Heaton. (Courtesy Historical Society of Washington.)

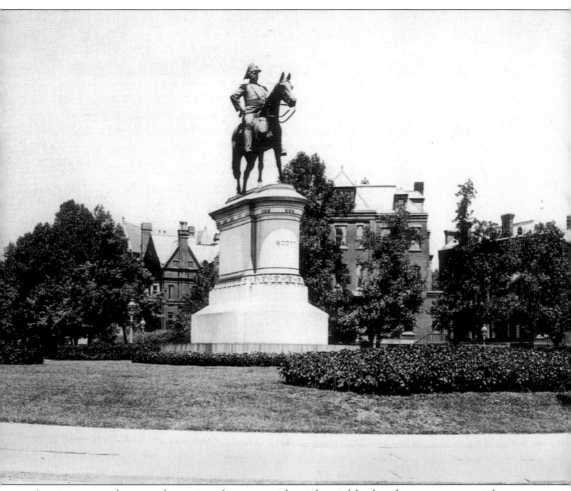

A witness to the transformation from a residential neighborhood to a commercial core, the statue of General Scott has remained steadfast throughout the process. (Courtesy Smithsonian Institution.)

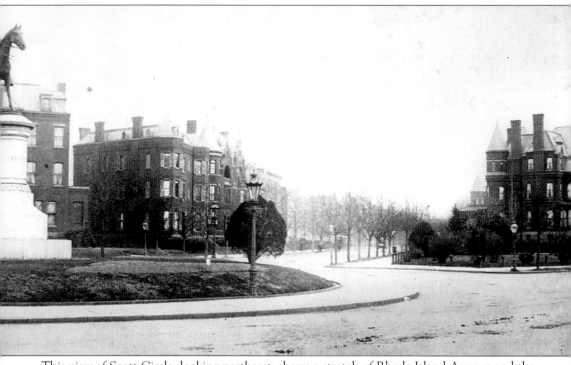

This view of Scott Circle, looking northeast, shows a stretch of Rhode Island Avenue and the house that was owned by Alexander Graham Bell. The home, at right, was later dramatically renovated for Vice President Levi P. Morton. (Courtesy Prints and Photographs Division, Library of Congress.)

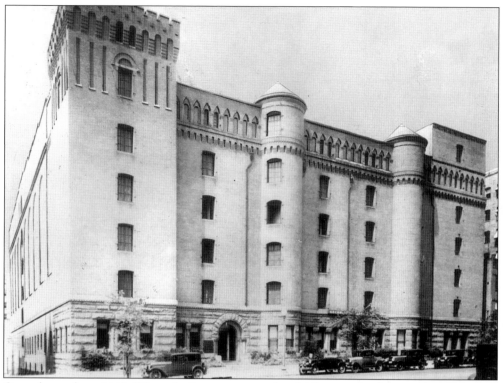

Once located at 1140 Fifteenth Street just south of Thomas Circle was the impressive Security Storage Warehouse, built in 1890. It was enlarged in 1907 and again in 1921 before it was razed in 1965. The building was designed by architect James G. Hill and housed many of Washington's family possessions while they were away on extended foreign vacations or awaiting the completion of construction on a new home. (Courtesy Historical Society of Washington.)

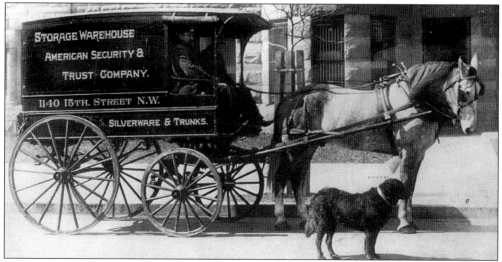

This rare early photograph of the Security Storage facility shows the rather arduous means in which household goods were transported and placed for safekeeping at the facility. (Courtesy Prints and Photographs Division, Library of Congress.)

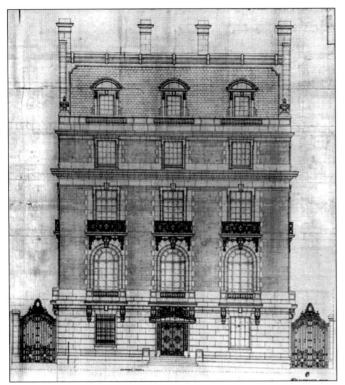

This impressive architect's drawing for 1746 Massachusetts Avenue was executed in 1906 for owner Clarence Moore by architect Jules Henri De Sibour. The house was completed in 1909 at cost of $200,000 and was the last known address for Moore, who perished on the *Titanic* in 1912. Moore had traveled to England to purchase 50 pairs of English foxhounds, who did not accompany him on the ill-fated ship. The house was later sold to the Canadian government in 1927 for use as their chancery. (Courtesy D.C. Building Permits.)

Architect Jules Henri De Sibour was one of Washington's first architects to attend formal Beaux Arts training in Paris. (Courtesy Smithsonian Institution.)

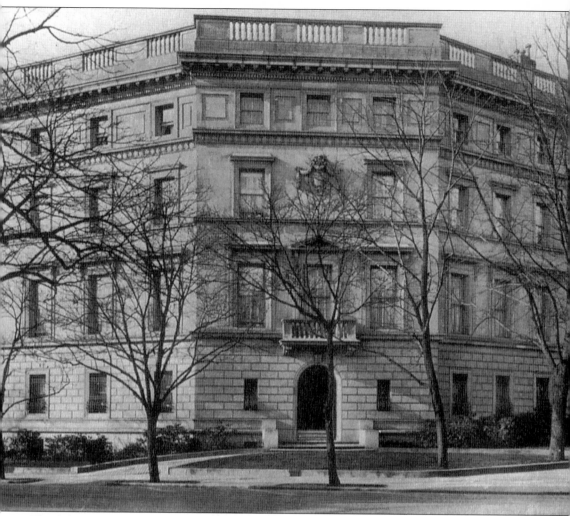

The house at 1700 Massachusetts Avenue was designed by noted architect Jules Henri de Sibour, photographed here before 1925. The house was designed and built in 1909 for owner Emily J. Wilkins at an impressive cost of $75,000. (Courtesy Prints and Photographs Division, Library of Congress.)

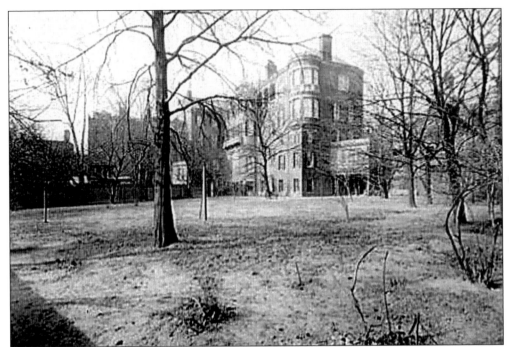

This rear view of the Fairmount School at 1711 Massachusetts Avenue shows the large rather rural nature of the site at the time when the house was converted to institutional use *c.* 1910. It served as a finishing school for Washington's young women and was photographed in a series of prints by Theodor Horydczak (1890–1971). (Courtesy Prints and Photographs Division, Library of Congress.)

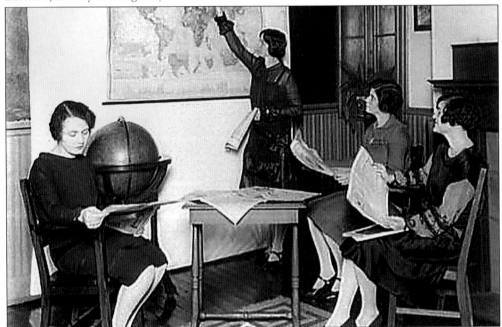

Girls from the Fairmount School are pictured here attending a geography history lesson. (Courtesy Prints and Photographs Division, Library of Congress.)

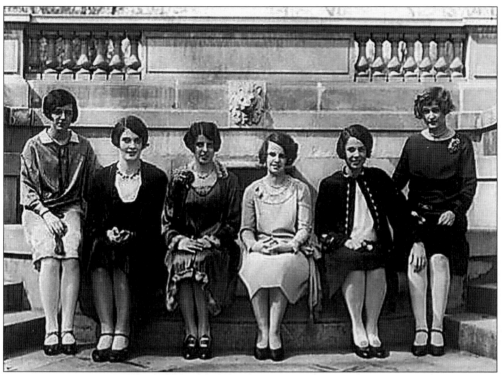

Fairmount School women pose on the front steps of their school at 1711 Massachusetts Avenue, c. 1925. (Courtesy Prints and Photographs Division, Library of Congress.)

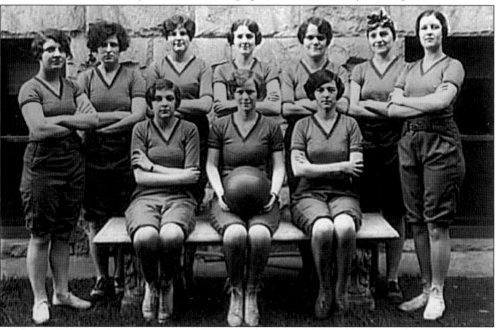

Athletics were part of the curriculum at the Fairmount School; the basketball team is pictured here wearing the team garments of the day. (Courtesy Prints and Photographs Division, Library of Congress.)

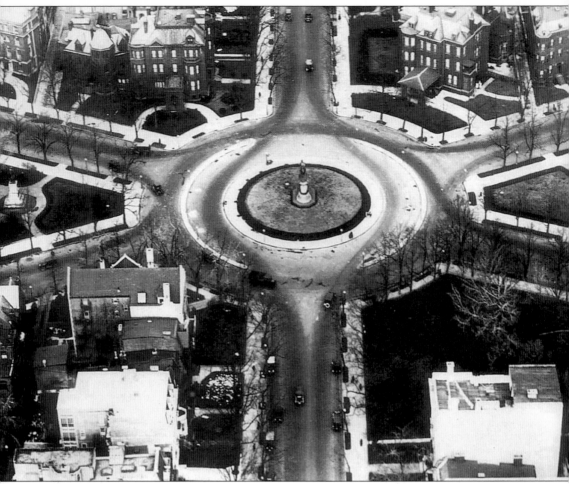

This captivating aerial view of Scott Circle was taken in 1932 and shows the fine Victorian homes built around the Circle since its inception over 50 years prior. (Courtesy National Archives.)

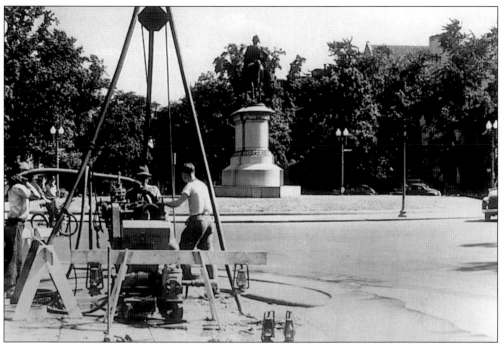

On June 21, 1940, the *Washington Daily News* carried the first photographic evidence of construction for the Sixteenth Street underpass that would eventually carry traffic below the Circle itself. Borings were then being made to a depth of 25 feet to determine how deep the foundation must go and what kind of construction it must be. (Courtesy Washingtoniana Division, MLK Jr. Public Library.)

In June 1940, Massachusetts Avenue at Scott Circle was depicted with only a small amount of traffic before the Sixteenth Street underpass was begun later that year. Thomas Circle is visible in the background of this *Washington Daily News* photograph. (Courtesy Washingtoniana Division, MLK Jr. Public Library.)

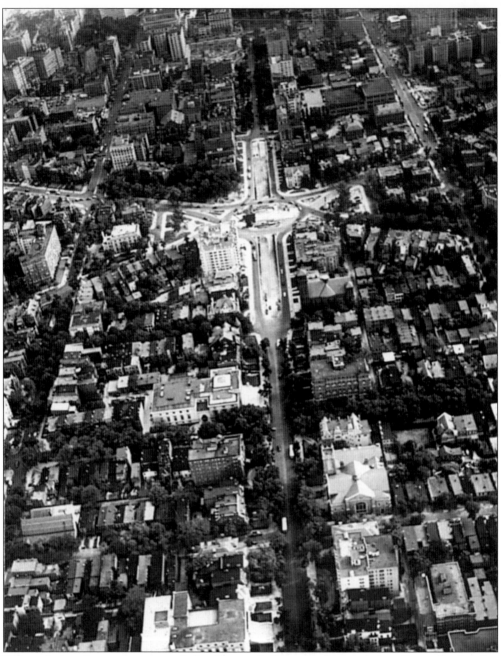

Taken during the construction of the Sixteenth Street underpass below Scott Circle, this aerial photograph illustrates the new street patterns with divided lanes for the readers of the *Washington Star*'s August 25, 1941 edition. (Courtesy Washingtoniana Division, MLK Jr. Public Library.)

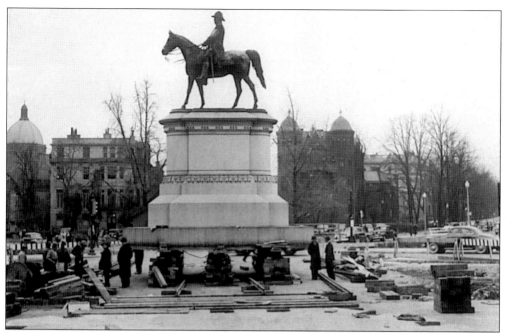

Just days before the underpass was officially opened, the Scott statue was returned to its place in the center of Scott Circle, having been removed during the construction phase of the project. This photograph ran in the *Washington Star* on December 20, 1941. (Courtesy Washingtoniana Division, MLK Jr. Public Library.)

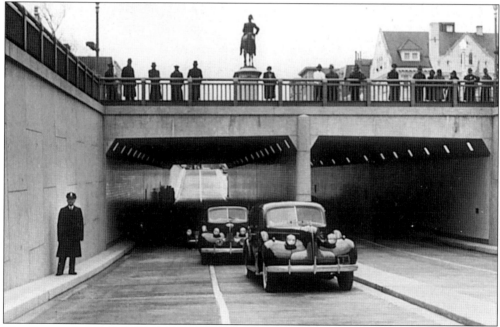

The Sixteenth Street underpass officially opened on December 29, 1941, and automobiles of district commissioners leaving the north entrance of the underpass were photographed that day for the *Washington Daily News*. The visible policeman is Capt. Oscar J. Letterman of the Third Precinct. (Courtesy Washingtoniana Division, MLK Jr. Public Library.)

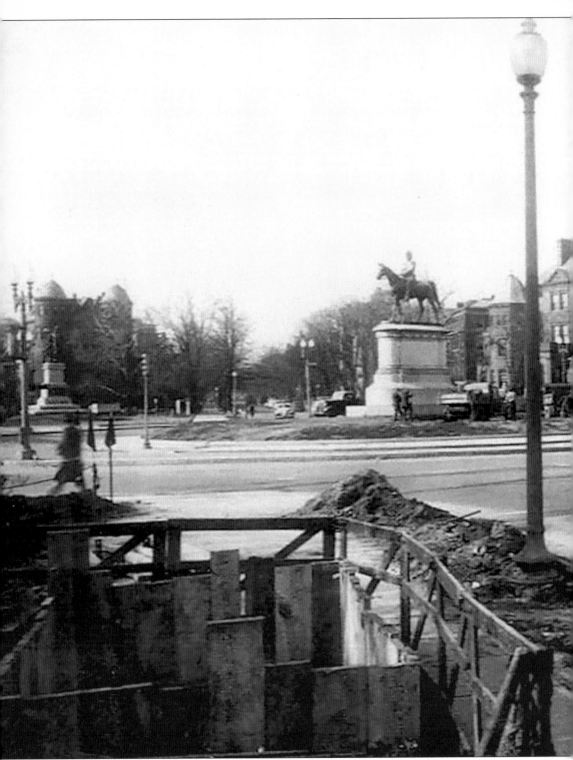

This view of Scott Circle was taken just as construction began on the Sixteenth Street underpass, as well as on the General Scott apartment building, whose construction site can be

seen on the right. The image dates from about 1941. (Courtesy Prints and Photographs Division, Library of Congress.)

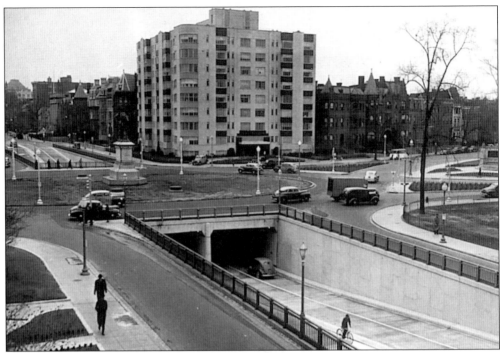

This view of the completed Sixteenth Street underpass below Scott Circle was carried by the *Washington Star* on December 28, 1941. Except for the large art deco–styled General Scott Apartment building on the north side of the Circle at Sixteenth Street, the buildings surrounding the Circle remained primarily residential in nature. (Courtesy Washingtoniana Division, MLK Jr. Public Library.)

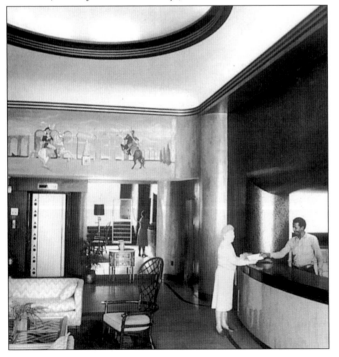

The General Scott apartment building was built in 1940 at Sixteenth and Scott Circle. It was designed by architect Robert O. Scholz and featured this large, curvilinear lobby desk for the convenience of renters and their guests. The building originally had 175 apartments and was converted in condominiums in 1982. (Courtesy Smithsonian Institution.)

With a row of homes still visible, this *Washington Daily News* photograph feature from December 26, 1947 shows what a white Christmas in Washington looked like at that time. (Courtesy Washingtoniana Division, MLK Jr. Public Library.)

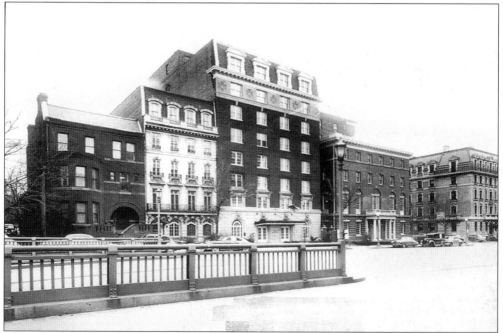

These fine buildings lining the 1200 block of Sixteenth Street just south of Scott Circle were photographed about 1950. All have since been replaced with a modern office building. (Courtesy Prints and Photographs Division, Library of Congress.)

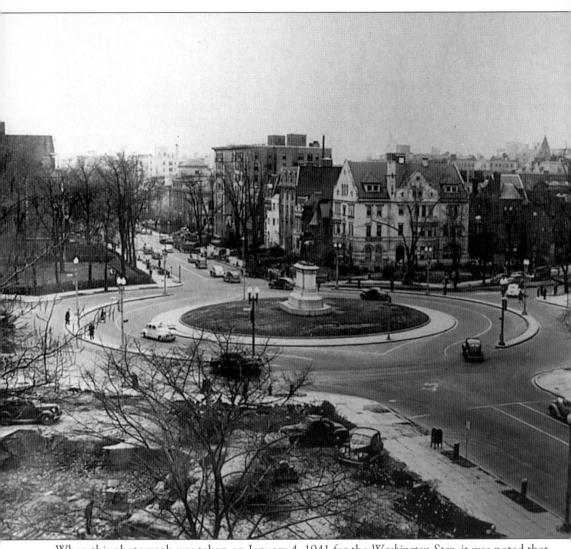

When this photograph was taken on January 4, 1941 for the *Washington Star*, it was noted that work had just begun on the Scott Circle underpass. (Courtesy Washingtoniana Division, MLK Jr. Public Library.)

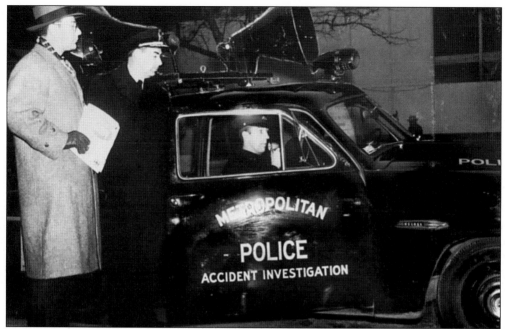

For Washington residents, according to the *Washington Daily News* on December 18, 1951, "this accident investigation unit cruiser equipped with microphone and loudspeaker will be touring the downtown areas thru Dec. 24th asking pedestrians and motorists to obey traffic laws." Pictured, from left to right, are Bernard Levy, Junior Chamber Traffic Safety Committee; Capt. William Liverman; and Officer William Everett. (Courtesy Washingtoniana Division, MLK Jr. Public Library.)

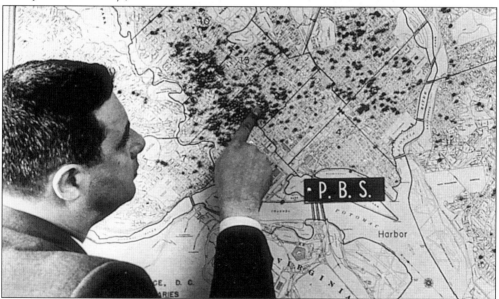

Capt. Murray Kutner studies his map showing the location of pocketbook snatchings in this photograph run by the *Washington Daily News* on April 13, 1962. At the time, the crimes seemed to be concentrated in the Logan, Thomas, and Scott Circle areas, directly under his finger. (Courtesy Washingtoniana Division, MLK Jr. Public Library.)

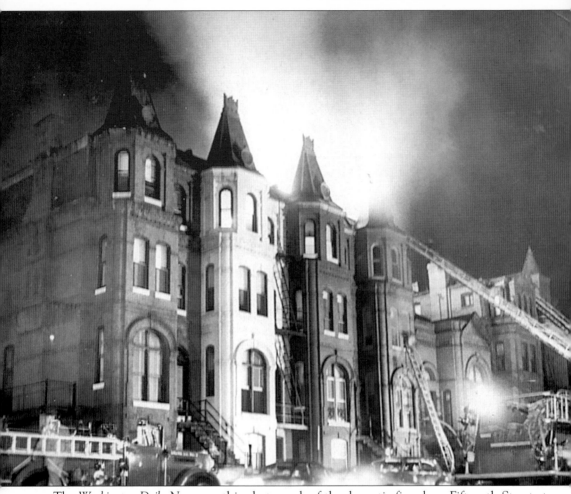

The *Washington Daily News* ran this photograph of the dramatic fire along Fifteenth Street at Scott Circle on March 31, 1932. Only the three houses at the left remain today. (Courtesy Washingtoniana Division, MLK Jr. Public Library.)

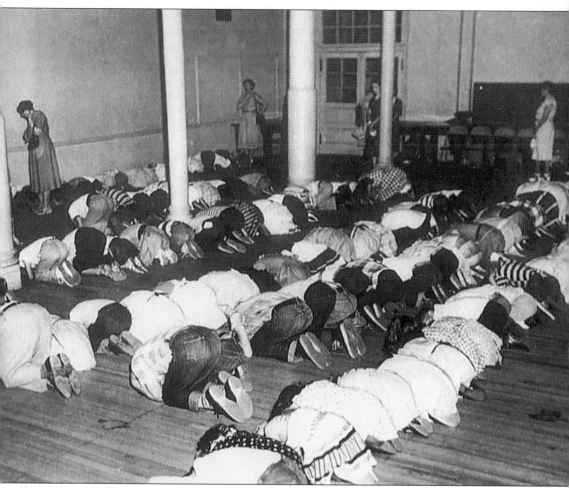

Students at the Thompson Elementary School at Twelfth and L Street were photographed undertaking the mandatory Cold War Civil Defense drill known as "Duck and Cover" in June 1954. (Courtesy Washingtoniana Division, MLK Jr. Public Library.)

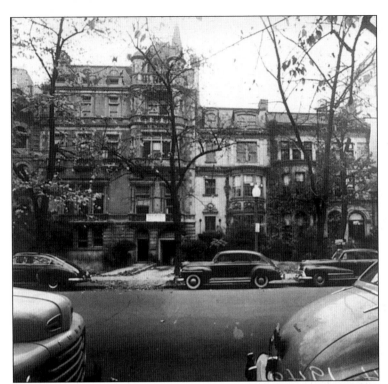

On November 4, 1949, the *Washington Star* ran this photograph of the homes once located at 1707, 1709, and 1711 Massachusetts Avenue, then being razed to make way for the 270 unit apartment building known as Boston House. (Courtesy Washingtoniana Division, MLK Jr. Public Library.)

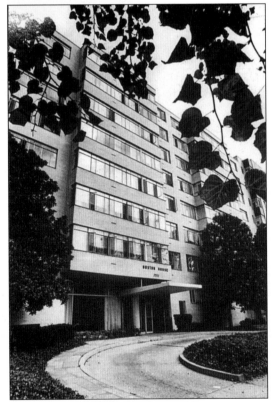

Boston House is rather typical of the apartment buildings that replaced the once elegant homes of the city's elite and now line Massachusetts Avenue. This photograph ran in the *Washington Star-News* on November 2, 1974, when developer Stuart Bernstein paid $3.5 million for the 270-unit building at 1711 Massachusetts Avenue. (Courtesy Washingtoniana Division, MLK Jr. Public Library.)

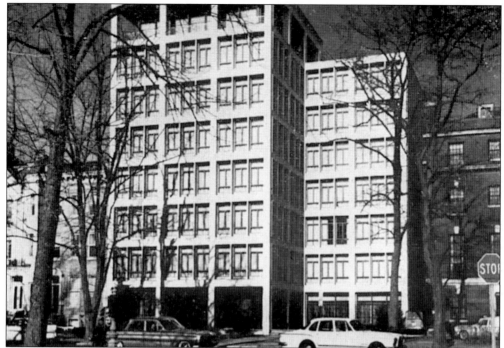

Situated on a then-mixed street of homes and businesses near Scott Circle, this new building was highlighted in the January 1963 *Architectural Forum* magazine. It had been designed by the firm of Keyes, Lethbridge & Condon and was typical of the mundane buildings that had replaced the elegant town homes of Washington's early well-to-do residents. This photograph was taken by John Burwell. (Courtesy Washingtoniana Division, MLK Jr. Public Library.)

Despite what many would consider today as a nondescript office building, this structure at 1717 Massachusetts Avenue, designed by the Cooper and Auerback firm, was awarded "First Award" by the Potomac Valley Architect when it opened in December 1964. (Courtesy Washingtoniana Division, MLK Jr. Public Library.)

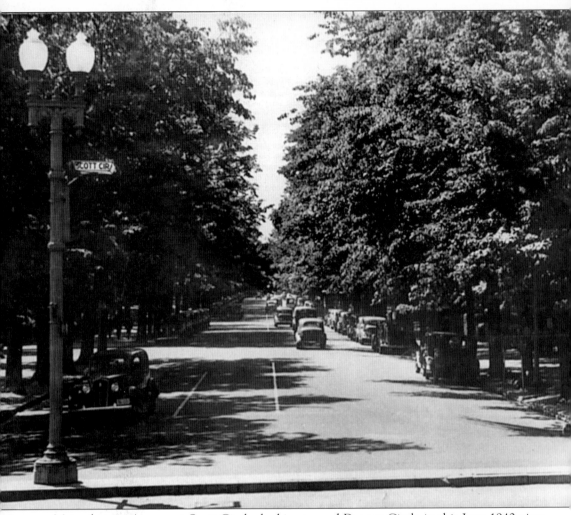

Massachusetts Avenue at Scott Circle, looking toward Dupont Circle in this June 1940 view, was once lined with trees. That era ended with the widening of the avenue and the increased vehicular traffic today. (Courtesy Washingtoniana Division, MLK Jr. Public Library.)